AN APPROACH TO
THE INDIAN THEORY OF
ART AND AESTHETICS

An Approach to the Indian Theory of Art and Aesthetics

SNEH PANDIT

STERLING PUBLISHERS PVT LTD
AB/9 Safdarjang Enclave, New Delhi-110016

Distributed in the USA by
International Publications Service, Inc.,
114 East 32nd Street, New York; N.Y. 10016

ISBN 0 8426 1005 7

An Approach to the Indian Theory of Art and Aesthetics
© 1977, Sneh Pandit
Published by S.K. Ghai, Managing Director, Sterling Publishers Pvt Ltd
AB/9 Safdarjang Enclave, New Delhi-110016
Printed at Sterling Printers, L-11 Green Park Extn., New Delhi-110016

Preface

Indian aesthetics, though rich in content, is a much neg-
lected and misunderstood field of study. This has perhaps
been largely due to the unsystematic manner in which the
whole subject has been treated in the traditional texts.
Whereas, the metaphysical statements of the *Vedas* and the
Upanishads skirmish around the concept of beauty, without
elaborating on it in the manner of an aesthetic treatise, the
classical works on art such as the *silpashastras* and *alamkara-
shastras* are full of practical injunctions and didactic state-
ments. Moreover, the erudite language of these texts and
the mythical manner in which the authors often develop
their themes, tend to cloak the essence of the thought and
do not permit of its logical analysis and development. For
these reasons it is generally believed that while Indian
thought is rich in mysticism, religion and metaphysical
thought, it has never really developed a true aesthetic.

The present study aims at dispelling this view. While
every work has its limitations and one cannot perhaps do
all that one sets out initially to do, the explicit purpose of
this work is to clarify the terms and concepts used in the
traditional Indian texts and to submit them as far as possi-
ble to an objective analysis. This analysis is undertaken
in the context of modern aesthetic theories which often pro-
vide not only a startling contrast but an amazing parallel to
the Indian theories.

In the process of analysis I have at times taken liberties
with the traditional texts, not in order to read meanings
into them that were never intended, but because these seem-
ed to be logically suggested by them. By dealing with the
problems of Indian aesthetics in a systematic way I do not
wish to suggest that this is how they appeared to the ancient
and mediaeval Indian thinkers. The plan of this study was
drawn up for the sake of clarity and convenience alone.

What is the value of such a study ? It can lie in various fields. It can, for one, add to the knowledge of the history of ideas and culture of a particular age and time. It can also help the modern mind understand Indian art within its own cultural and intellectual setting, and it can enhance our understanding of art and aesthetics in general. Needless to say, the need for a systematic approach in a field such as Indian aesthetics, wherein the subject has never been fully organised, cannot be over emphasised.

Among the vast prevailing literature on Indian art and aesthetics, apart from a few essays, there has been no study of the kind undertaken. The contribution of Indologists in the field of Indian art has been considerable. Most of it however has been done by historians and archaeologists, museum curators and art-historians, mainly with a view to organise the vast material of Indian art and aesthetics, fix this material in chronology, identify the themes and relate them to their cultural setting. Special studies have also been undertaken for the purpose of explaining the various systems, styles, modes of technique, methods of composition, the iconology and symbols of the separate arts.

Nonetheless, these works which are not perhaps complete aesthetic theories in the sense in which the subject is understood today, provide a valuable background for any student of Indian aesthetic thought. I have depended on them to draw my facts and references from. It is not necessary to mention them all here since I have done so in footnotes and in the bibliography appended at the end. Mention must, however, be made of a few which have been especially useful in my context, namely, A.K. Coomaraswamy's admirable treatise, *The Transformation of Nature in Art*, Stella Kramrisch's *Indian Sculpture*, Raniero Gnoli's fragmentary but admirable, *The Aesthetic Experience According to Abhinavagupta*, M. Hiriyanna's *Art Experience*, K.C. Pandey's *Indian Aesthetics*, S.K. De's *Indian Poetics as a Study of Aesthetics* and P.J. Chaudhary's *Studies in Aesthetics*.

My great debt of gratitude is to Dr Niharranjan Ray, former Director of the Indian Institute of Advanced Studies, Simla, and Emeritus Professor of Calcutta University, not

only for making me aware of the challenge involved in the undertaking of this particular field of study but for the clarity of the ideas he put across to me and for his over-all guidance and supervision.

I must also thank Dr Prem Nath, Head of the Department of Philosophy, of the Panjab University for his many invaluable suggestions and for his constant encouragement and help.

SNEH PANDIT

Contents

An Approach to
the Indian Theory of
Art and Aesthetics

Introduction

THE PROBLEM of aesthetics is not a recent product of human speculation but a fundamental philosophical problem which arose out of man's interest in beauty, its creation and appreciation. If epistemology deals with the problems of knowing, and ethics with those of moral action, aesthetics investigates the ineffable realm of imagination and feeling—an investigation made none the clearer by the light thrown upon it, by those who actually live in the world of feeling and articulate primarily through their vision and imagination, namely the artists. They create works of art out of the urge of their creative vision and imagination and do not, perhaps cannot generally analyse what they create. An artist can seldom formulate the actual steps of his creation and offer them to the public in neat recipes and formulae. Yet this lack of formulation does not mean that he creates in an indisciplined and wilful manner. Rather he feels compelled to conform to some criterion, to seek for some ideals, in other words, to work within a disciplined system.

If it were not so, his work would be purely personal and hence meaningless for others, perhaps even for himself. He would not be the creator of things which are universally recognised to be beautiful but the author of a private dream, and his expression would be of no more value to mankind than the expression of a child in play.

On the other hand, philosophers who try to formulate the activity of artists in neat and precise logical formulations, are also in serious danger, of losing the correct perspective in their attempt to contain within an abstract system, experiences which are concrete, unique and particular.

It is not with reason that beauty can be known, but it can be experienced through feeling. The very attempt to understand it, to systematise it within defined boundaries is a self-defeating attempt. It is no wonder therefore that artists cry out in protest and ask the philosophers to confine their intellectual analysis to fields other than that of art. Why should we analyse our experience of beautiful things at all ? They ask. Is it not enough to create them and to be content with our feelings of them ? Is not each beautiful thing unique that it stands by itself ? And is not the attempt to set up general criteria for the creation and appreciation of beauty, a violation of beauty itself ? Is not theoretical speculation a murdering to dissect ? In brief, it is asked if aesthetic theory is possible at all ? And herein lies the aesthetic problem presenting itself as a fundamental paradox. On the one hand is the surge of creative desire and flight of imagination as experienced by the artists in an actual confrontation with art and beauty, on the other there is the desire to understand that feeling, and to order the imagination within precise categories as stipulated by philosophers. Beauty defies rationality, and reason dispels beauty, so it seems to be argued.

The argument in favour of experiencing beauty in the most concrete terms possible is well stated by Walter Pater in the preface to his *Renaissance*. He points out the futility of discussing terms like beauty and trying to find a universal formula for them. Beauty is a relative value and its defini-tion becomes unmeaningful and useless. The aim of the true student of aesthetics, he maintains, is "not to find its universal formula, but the formula which expresses most adequately this or that special manifestation of it."[1]

1. "Many attempts have been made by writers on art and poetry to define beauty in the abstract, to express it in the most general terms, to find some universal formula for it. The value of these attempts has most often been in the suggestive and penetrating things said by the way. Such discussions help us little to enjoy what has been well done in art and poetry, to discriminate between what is more and what is less excellent in them, or to use words like beauty, excellence,

(Contd.)

The dispute between beauty and reason would perhaps be resolved in favour of this position were it not for the fact that despite resisting all attempts to be clearly analysed, the aesthetic experience yet implies a universal criterion. The very use of the term beautiful to any object implies a value which is universal, communicable and objectively knowable. When we say for instance, "The Taj Mahal is a beautiful piece of architecture", it is clear that we expect others to agree with this statement. If it were not so, we would simply say, "To me the Taj Mahal is beautiful" in much the same way as we say "I like the taste of mango". That beauty is not wholly relative, is also evident from the fact that certain works of art have stood the test of time, of changing tastes and fashions and have come down to us through the centuries as universally accepted masterpieces.

While it is indubitable that beauty is an individual thing and not a general concept yet we cannot overlook the fact that "there are certain *kinds* of objects which many people agree in calling beautiful, and certain *kinds* of mental experience called aesthetic". This seems to lead to the assumption that there is an aesthetic quality which is recognisable.[2]

(Contd.)

art, poetry, with a more precise meaning than they would otherwise have. Beauty, like all other qualities presented to human experience is relative; and the definition of it becomes unmeaning and useless in proportion to its abstractness. To define beauty, not in the most abstract but the most concrete terms possible, to find not its universal formula but the formula which expresses most adequately this or that special manifestation of it, is the aim of the true student of aesthetics. 'To see the object as in itself it really is' has been justly said to be the aim of all true criticism whatever. 'And he who does this distinctly, who can experience vividly' has no need to trouble himself with the abstract question what beauty is in itself, or what is its exact relation to truth or experience—metaphysical questions elsewhere. He may pass them all by as being answerable or not, of no interest to him."

Louis Arnaud Reid, "Artists, Critics and Philosophers", in *Problems of Aesthetics*, edited by Eliseo Vivas and Murray Krieger, Holt, Rinehart and Winston, New York, 1963, pp. 21-22.

2. *ibid.*, p. 24.

The aesthetic dilemma when stated briefly is simply this: man's direct commerce with art and beauty assures him of its universal value, yet knowledge of it escapes him, for in the very attempt to hold it within rational understanding it is dispelled. In the very consciousness that there is a beauty which is communicable and general is the awareness that its presentation to the intellect is impossible, for the moment we try to understand it we lose the complete enjoyment of it.

The question is: can the apparently contradictory poles of feeling and formulation of experience and knowledge of sense and contemplation be reconciled within the same situation ?

This paradox seems to have been offered a solution in traditional Indian speculative thought. Making no sharp distinction between art and ethics, aesthetics and metaphysics, this thought affirms that "beauty" is capable of being known to man intrinsically and positively in the innermost essence of his being. Knowledge and enjoyment are not contradictory terms but synonymous in the highest act of transcendence which secure absolute freedom (moksha) from phenomenal ends.[3]

The more deeply the "self" is absorbed in its being and the more conscious it becomes of its own true worth the more complete is the delight afforded to it. Absolute truth (sat), pure consciousness (chit) and bliss (ananda) are the three aspects of the same reality to which all existence tends.[4]

3. In Indian thought the concept of "beauty" comes from the metaphysical concept of *ananda* which is pure delight. According to the Upanishads cosmic creation derives from *ananda*, has its being, life and sustenance in it. "Who indeed could live, who breathe, should not this *ananda* be in *akasa* ? (*Taittiriya Upanishad*, ii)" All shine after Him who shines. By His radiance is all this illumined," (Mundaka, 11.2.10). *Ananda* is the beginning and the end of the world, the cause as well as the effect, the root as well as the shoot of the universe. (*mula and tula*). (*Aitareya Aranyaka*, 11.1.8.1) (tr. S. Radhakrishnan).

4. S. Radhakrishnan, *Indian Philosophy* Vol. I. George Allen & Unwin, 1958, p. 150-151.

(Contd.)

This fundamental postulate of Indian thought seems to be explained in the speculations of the *Upanishads*. Here the problem of knowledge (*jnana*) and the problem of experience are bound together in an indissoluble unity. That which the "self" realises subjectively in the innermost essence of its being in an act of intrinsic realisation is the same as the essence of objective reality which it grasps in an act of total awareness.[5] The conflict is not between reason and experience or knowledge and feeling but between a relative experience and an absolute experience, a lower knowledge (*apara*) and a higher knowledge (*para*).[6] An act of intrinsic perception (*darshana*) is also an act of intrinsic experience (*anubhava*).

The problem of beauty in the speculations of the *Upanishads* is one of knowledge inextricably involved within the ethical situation. The question is not whether experience can be formulated and understood but whether it can be enjoyed absolutely.[7] Unlike Plato, the Upanishadic seers never sought to discover a concept of beauty but rather a method and a process whereby it could be realised. This

(*Contd.*)

"The prayer of every human heart is 'Lead me from the unreal to the real, lead me from darkness to light, lead me from death to immortality'." *Asato ma sad gamaya, tamaso ma jyotir gamaya, mrityor ma amritam gamaya*", Brih. Up., 1.3.27.

5. ibid., p. 146 "*Brahmanah Koso'si*", Thou art the sheath of Brahman (*Taittiriya Upanishad*).

"Whosoever worships another deity, in such a manner as he is another, another 'I am' does not know" (*Brihadaranyaka Upanishad* 1.4.10) (tr. S. Radhakrishnan, op. cit.)

6. "Two kinds of knowledge must be known, the higher and the lower. The lower knowledge is that which the *Rig. Sama, Atharva Vedas* Ceremonial; Grammar give......but the higher knowledge is that by which the indestructible *Brahman* is apprehended." (*Mundaka*, I.1.4-5 *Maitrayana* vi. 21) (tr. S. Radhakrishnan, op. cit.) As will be shown later aesthetic knowlege is a modality of metaphysical knowledge.

7. The highest good in the philosophy of the *Upanishads* "is a state of rapture and ecstasy, a condition of *ananda* where the creature......becomes one with the Creator, or more accurately realises his oneness with Him." S. Radhakrishnan, *Indian Philosophy*, Vol. I, p. 237.

pragmatic approach which distinguishes the whole of Indian philosophy, when applied to aesthetics and art succeeds in avoiding the paradoxical situation resulting from the fundamentally rational approach of Western thought.

Aesthetics in Upanishadic thought not being divorced from ethics, sought not for the meaning and truth of external reality but for the essence which lay hidden behind the passing show of appearance. It's aim was to influence human conduct and thought, and through the disinterested contemplation of beauty in nature and art, to bring about the necessary state of mind required to transcend the ego and the mind.

While the ultimate aesthetic consciousness like the ethical ideal is purely contemplative the steps prescribed to achieve it through the artistic process are marked by a high degree of activity, an intense act of concentration. It is not therefore without reason that the language of *yoga* is applied to the artist and to art activity as it is to the seeker of truth and the saint to their spiritual exercises; the basic objective in both cases is the cultivation of a dispassionate and disinterested feeling rather than rational understanding. The true creator and appreciator of beauty is not the most rational thinker or skilful craftsman but the one who possesses the greatest sensitivity, literally the greatest heart (*hridaya*).[8]

These aesthetic speculations lying implicit in the ethical thought of the *Upanishads* were unearthed centuries later by the classical and medieval Indian rhetoricians whose initial cognate interest in the principles of literary criticism, led them at first along totally different lines of thought but landed them eventually at the same intellectual position. Parenthetically, aesthetics concerning the nature of art and

8. Cf. Raniero Gnoli, *The Aesthetic Experience according to Abhinava-gupta*, Serie Orientale, Roma XI 1956, p. 74 note i.
 "The terms heart (*hridaya*), thought (*vimarsa*), bliss (*ananda*), vibration (*sphuratta, ghurni*), etc. express the same concept." Also cf. pp. 84, 87, 104.

its creation started from the empirical study of grammar, language and rhetoric and prosody leading to the allied fields of drama and dance, poetry, music and the plastic arts.

Till the time of Bharata[9] the study was purely academic concerning grammatical rules, techniques of versification, dramatic production and the style of presentation alone.[10] The fundamental question posed by Bharata, namely, what is that essential quality of a work of art (a poem or drama) which constitutes its universal appeal, gave a completely new direction to the hitherto objective field of art. His solution lay not in the discovery of a conceptual norm, as his predecessors had tried to do, but in the evocation of a subjective state called *rasa* aroused by the combined audio-visual effect of the drama.[11] This *rasa* concretely understood as juice or flavour, eventually became the focal theme of controversy for all later Indian aesthetic thinkers and raised the practical study of art from its mundane setting and brought it on a par with other philosophical disciplines. At the same time Bharata's colossal attempt to codify the principles of poetry and drama succeeded in investing a

9. Bharata is the reputed author of the most ancient text on dramaturgy, that has come down to us, the famous *Natyasastra*. The exact date of the compilation of the extant version of the text is unknown but it may perhaps be placed anywhere between the third to sixth century A.D., though there must have been an earlier, perhaps pre-Christian version. It is a collection of rules and instructions pertaining mainly to drama, music, dance and poetry. A great deal of emphasis in this work is laid on aesthetic mood and feeling. It presents indeed a comprehensive psychological analysis of the subject.

10. "In fact the sole aim of Bharata's *Natyasastra* is to instruct (*Abhinavabharati* Vol. 1.7) the dramatist, the stage-manager and the actors in regard to the ways and means of producing the drama, to tell them the necessary constituents of the drama and the manner and material of their presentation." K.C. Pandey, *Comparative Aesthetics*, Vol. I, The Chowkhamba Sanskrit Series, Benares, 1950, p. 2.

11. *Natyasastra*, VI, V. 33 : "Out of the union of the Determinants (*vibhava*), the consequents (*anubhava*) and the transitory mental states (*vyabhicaribhava*) the birth of *rasa* takes place." (tr. Raneiro Gnoli, *The Aesthetic Experience according to Abhinavagupta*, Roma, Is M.E.O. 1956, p. 29).

field which had hitherto been considered to be related to mere sensory experience and hence superficial, with a status of respectability and to gain for his voluminous work the distinction of a philosophical cum-religious treatise. Indeed, the authentic *Natyasastra* is even today in India the most authoritative work of its kind.[12] Bharata's realistic approach and eventual location of the aesthetic and artistic quality in a psycho-physical state is comparable to Aristotle's attempt in the West. *Rasa*, as conceived by Bharata is a kind of physio-psychological state induced by the actual secretion of bodily glands which is not perhaps unlike the *katharsis*, is indeed derived from the medical terminology current at the time.[13]

The problem of aesthetics is for these earliest thinkers primarily psycho-physiological. The experience of beauty is an actual state of pleasure, induced by the systematic presentation of artistic form and is not an objective quality which can be inferred analytically or discerned conceptually.

12. The term *natya* is really a composite term including dance and music. It was given the authoritative status of *sastra* or *veda*, in order to establish the higher ethical value of art and aesthetics as against the mere pleasure of entertainment. For this Bharata declared *natya* to have a supernatural origin, the word having been given by Brahma himself (*A.Bh.* Vol. I. 1)

13. Cf. S.H. Butcher, *Aristotle's Theory of Poetry and Fine Art*, Indian Edition, Delhi, 1967, p. 245.

 Three meanings are given to the term *katharsis*— (1) The medical (2) the moral, purification (3) the religious, lustratio. In certain works a particular meaning is prominent. As for instance in Plato's Sophist 230 c the medical metaphor is more emphasised The term *rasa* undergoes similar changes of emphasis in meaning. In the *Rig-veda*, *rasa* implies the idea of "taste" or "savour". For instance the poet asks "may the satisfying taste (*asvadu*) of the mixed honey come to me." (*Atharva Veda* 111.13.15) In the *Upanishads* the meaning of *rasa* came to imply the essence of a thing. "Life, breath or the vital air is the *rasa* or essence of the limbs" (*Bh.Up.* 1.3.19) And later it came to mean the ecstatic state of bliss, "He is rasa, having obtained Him the soul becomes full of bliss" (*Taittiriya Upanishad*, V. 7) Cf. Mulk Raj Anand, *The Hindu View of Art*, Asia Publishing House, Bombay, 1957, p. 57.

Bharata's concept of *rasa* enunciated in a famous aphorism, became a subject of study and analysis to a whole series of thinkers. But its full import was not realised till the time of Abhinavagupta in the 11th century,[14] who freely elaborating on the original concept used it not only to establish the unique character of the aesthetic emotion, but also the essential quality found in an art work, which produces the aesthetic emotion.

Abhinavagupta's predecessor, Anandavardhana[15] had in his treatise *Dhvanyaloka*, centred his attention around the fact that words which are the material of poetry, used in a certain way possess the power to evoke aesthetic emotion and are not merely symbols for the conveying of fact in a literal manner. This was certainly an important discovery, since his predecessors, namely, Dandin belonging to the 7th century and Bhatta Lollata and Sankuka, both belonging to the 8th century, had been unable to distinguish aesthetic knowledge from intellectual knowledge and were trying the impossible task of deriving the art quality from logical and empirical categories. The aesthetic emotion too, was taken by them to be an ordinary mental condition different only in degree from feeling as a psychological condition.

Anandavardhana's enquiry into the meaning of words and his analysis of the two-fold function of language viz., logical and suggestive, introduced a new level of discussion. The problem which had hitherto sought a solution within the clear range of logical boundaries, now broke out into

14. Abhinavagupta was the chief among Anandavardhana's followers. He accepted his theory of *dhvani* (cf. note 15) and elaborated it into his own theory of *rasa*. He was a Kashmiri Brahmin and lived during the second half of the tenth century. Apart from being a rhetorician, he is the chief representative of the Saiva metaphysics and religious thought. His most famous works in aesthetics are the (1) *Abhinava-bharati*, commentary on the *Natyasastra* of Bharata and (2) *Dhvanya-lokalocana* of Anandavardhana. He remains without doubt one of the most important thinkers on aesthetics in India.

15. Anandavardhana lived in the middle of the ninth century. He is the author of the *Dhvanyaloka* and was the first to formulate the theory of *dhvani* or poetic meaning.

the ineffable beyond of feeling If his predecessors had tried to define the essence of art in clear-cut terms, Anandavardhana drew attention to the inexpressible qualities of a good poem. The essence of poetry he held, lay not in its representational or descriptive powers, no matter how aptly they were presented, but in the emotional mood the poem could arouse. Consequently he drew attention to the fact that it was not the outward formal construction of a work that lent it beauty, but an intangible inexpressible quality given to it by the suggestive power of the words.

This inexpressible suggestive quality called *dhvani* cannot be analysed scientifically nor explained in ordinary psychological terms since the feeling aroused by it is not an actual one as that aroused by natural causes but one which is caused by literary and dramatic events. In other words an emotion like a real emotion is aroused and not an actual one. The phenomena is not psychologically but artistically real.

About the same time as Anandavardhana another aesthetician, Bhatta Nayaka,[16] drew attention to the generalized state of the aesthetic consciousness. This state, arising from an illusory situation, is unconditioned, be contended, by the events and reactions of everyday life. Consequently it derives its universality by the elimination of time, space, and the particular subjective state. Aesthetic experience, he pointed out for the first time, marks a definite break with the world (*samsara*) which is dominated and conditioned by the law of cause and effect.

These deductions were the pillars upon which Abhinavagupta erected his aesthetic theory. Accepting Anandavardhana's bifurcation of the aesthetic from the logical and Bhatta Nayaka's aesthetic experience as a state of generalised consciousness, not unlike the subjective universality which Kant was to discover centuries later, Abhinavagupta built a comprehensive theory of pure feeling undisrupted by rational considerations, existing as an independent, consistent whole which soon found a kinship with the religious state rather than with the logical. The norm of artistic

16. Bhatta Nayaka is placed around 900 A.D.

creation which his predecessors had tried to discover as an objective quality, was for him none other than the creative energy of the poet (*pratibha*) which filling him entirely with itself, is transferred spontaneously into poetic expression.

Abhinavagupta's singular contribution lies in freeing the artistic consciousness from all natural and practical relationships and in investing it with meaning and positive value, the meaning and value lying not in any end outside but wholly within the work itself. The aesthetic consciousness being of a different order from discursive consciousness, transcends the domain of intellect and language and illumincs, so to speak, the "thing-in-itself" (*svarupa—svalakasana*). Freed from all practical interests, the aesthetic consciousness disengages itself also from the bondage of the ego and worldly passions. Detached and distanced from the phenomenal order of things, it exists autonomously on a different plane and is not less real than the world, even though it belongs to no part of it. In fact, its reality is greater than the world because by discarding the outward appearance, transitory events and fleeting moods (*bhava*) it reveals the universal essence of things. In this the art work and the aesthetic emotion are identified into an inseparable whole. This act of identity invariably accompanied by the greatest joy Abhinavagupta shows to be the true meaning of *rasa*.

The term *rasa* however continued to designate apart from the experience, the aesthetic quality present in the work of art, which may be said to be *rasavant*; the critic, connoisseur or spectator who appreciates the work may be called *rasika*, the act in and through which the aesthetic emotion is enjoyed or contemplated may be technically styled *rasasvadana*.

Consequently in an art work, *rasa* is that unique quality which moves the audience; in the spectators' experience it is the distinctive emotion produced by the art object, and in the artist's intuition it constitutes his creative energy. Strictly, it is an all inclusive indivisible experience analysed separately for purposes of academic discussion alone.

This solution to the aesthetic paradox which Bharata

had indicated but not resolved and which had totally evaded those who came after him was accepted unquestioningly by Abhinavagupta's successors; indeed, they added little of real value to his theory. Consequently Abhinavagupta till today remains the most important and characteristic Indian aesthetician. His basic conception of art as an independent spiritual activity freed from all egoistic taints, an attitude rather than a quality has been since the time of Kant the main postulate of Western aesthetics as well. Many of his findings though developed in a totally different time and context, find an echo in modern theories. Clive Bell's "significant form" provokes a state of mind which is not very much unlike the *rasa* experience. "Art" says Bell, "transports us to a world of aesthetic exaltation. For a moment we are shut off from human interests; one's anticipations and memories are arrested; we are lifted above the stream of life."[17]

In working out the full implications of the concept of *rasa* Abhinavagupta is also led to accept the ethical value of the aesthetic experience and thereby he returns to the basic Indian stand-point articulated in the *Upanishads*. He does not however totally identify the two but holds that aesthetics belongs to the same realm as ethics and religion, the two being twins born of the same source, as it were.[18] The calm reposeful state of *rasa* (*visranta*) is essentially good as not only does it release the personality from daily tensions but enables the individual to realize its intrinsic nature (*svabhava*) the realisation of which, according to the *Upanishads*, leads to pure bliss (*anandam*). It is a liberating experience, for in its final moment the inner essence of the individual is completely identified with the essence of the art-work. This identification is the core of the *atman* theory given in the *Vedanta* and when freely applied to art, gives a striking similarity. *Rasa* then, is taken to be the *atman* or soul of the art work.

17. Clive Bell, *Art*, Chatto and Windus, London, 1914, p. 36.
18. Raniero Gnoli, *The Aesthetic Experience according to Abhinavagupta*, op. cit. p. xxiv, xxv, also p. 100.

Clive Bell's concept of art also leads him to realise its ethical value. "A work of art" he says "is ethical because it is a means to a good state of mind. Art is above morals or rather all art is moral because......works of art are immediate means to good......A work of art has immense ethical value because it provokes aesthetic ecstasy."[19] Further he compares art to religion, using almost the same terminology of the *rasa* theorists. "Art and religion" says he, "belong to the same world. Both are bodies in which men try to capture and keep alive their shyest and most ethereal conceptions. The kingdom of neither is of this world. Rightly therefore, we regard art and religion as twin manifestations of the spirit." The identification of subject and object sought for by the Indian aestheticians to the exclusion of all else is realised partially by Leo Tolstoy. "And however poetic, realistic, striking, or interesting a work may be, it is not a work of art if it does not evoke that feeling (quite distinct from all other feelings) of joy and of spiritual union with another (the author) and with others (those who are also infected by it)."[20]

The theory of poetic appreciation and creation developed by the medieval rhetoricians is perhaps the only independent aesthetic theory in Indian thought, wherein problems are raised concerning exclusively the nature of the experience afforded by works of pure art, the nature of the art activity, the nature of the work of art and the criteria for the evaluation of such works. Nonetheless it must be noted that though this theory of art was developed autonomously and therefore bears some resemblance to modern aesthetic theories even, it does not imply as modern aesthetics seems to do, an isolation from metaphysical and utilitarian principles. While the concept of *rasa* which epitomises the whole of Indian thought, does suggest that the aim of art is nothing beyond that of pure aesthetic delight, *rasa* derives itself from the metaphysical concept of *ananda* and is in the

19. Clive Bell, *Art*, op. cit. pp. 82-83.
20. Leo Tolstoy, *What is Art ? and Essays on Art*. Tr. Aylmer Maude, London, O.U.P. 1938, p. 227.

ultimate analysis an integral experience, transforming the individual personality as a whole. The delight afforded by the *rasa* experience pervades all aspects of life and being and is not confined to any single phase of life or to any exclusive human faculty. The self-sufficiency of the aesthetic experience does not suggest an isolation from other kinds of experience; it is not an existence in vacuum, but an all inclusive compactness. The aesthetic experience is different from other experiences inasmuch as it is a total state of being. Within the complete fullness of the aesthetic state all elements, such as the mental and sensuous are transformed, and not simply evaded. The aesthetic delight arises out of the transformation which the personality undergoes in its experiences of everyday life. The withdrawal from daily experiences that is suggested is only an initial withdrawal at a lower level in order to repossess them at the highest level. For instance, an ordinary psychological emotion (*bhava*) which is in everyday life suffered passively, is in the poetic and dramatic form transformed and enjoyed as *rasa*. The point to be noted is that even though the medieval Indian rhetoricians developed the theory of an aesthetic state as an independent, autonomous area of experience, and in this respect are similar to modern aestheticians, it did not lead them, likewise, to the development of a theory of art for arts' sake.

The concept of an aesthetic experience as pure sensuous delight, devoid of any intellectual, utilitarian and metaphysical content is not the obvious conclusion to which their point of view leads. The presentation of an undiluted sensuous content devoid of ulterior interest, is a prerequisite to the aesthetic experience as it enlists the undivided attention of the spectator and involves him in a direct participation with the work of art. Direct, discriminating perception at the sense level must however lead to the plane of intuitive knowledge, wherein beauty is felt as an immediate experience. The level of intuitive knowledge in Indian thought, wherein the highest value obtains, is a state of being, knowing and feeling beyond that of normal sense-perception and intellectual categories. It is essentially a

metaphysical state, inasmuch as it involves the transforma-
tion of the entire personality when it comes into direct con-
tact with the Real. It is at this level that the experience of
ananda is afforded. When this delight comes to the spectator
through the appreciation of a work of art, it is termed *rasa*.

That art while fully satisfying the aesthetic function
fulfils at the same time an ethical and metaphysical func-
tion is a point of view which becomes clearer in those
technical discussions which deal with the methods and
principles of production pertaining to the plastic arts, such
as sculpture, painting and architecture. These discussions
are contained fully in the texts, technically called *silpasasa-
tras*, written in classical and early medieval India.

An important point emerges from these texts, namely,
the great technical skill and efficiency required for the pro-
duction of an art work. Indeed the term *silpin* is nearer in
its meaning to craftsman than to artist in the sense we
understand the term today. The perfection of work as an
external act is a necessary aspect of the work of art. The
technique of art production is two-fold incorporating simul-
taneously the acts of visualisation and of execution. The
former giving the inner meaning and vitality to the out-
ward form, and the skilful, accurate execution of the work
according to prescribed standards helping to discipline the
mind for its act of visualisation. The emphasis on the dis-
ciplined externalisation of the work makes the art activity
an ethical one, and the artist akin to a *karmayogi*, that is to
a man who works under strict ethical regulations. "The
silpin according to one *silpasastra*, should understand the
Atharva Veda, the thirty-two *silpasastras* and the Vedic
mantras (hymns) by which deities are invoked. He should
be one who wears a sacred thread, a necklace of holy beads
and a ring of *kusa* grass on his finger, delighting in the
worship of God, faithful to his wife, avoiding strange
women, piously acquiring a knowledge of the various sci-
ence, such a one is indeed a craftsman."[21] In another place

21. Quoted by Mulk Raj Anand, *The Hindu View of Art*, Asia Publishing
House, Bombay, 1957, p. 71.

it is said that the painter must be "no sluggard" not given
to anger, holy, learned, self-controlled, devout, and charit-
able, such should be his character.[22] There is in all this a
great deal of priestly and pedantic scholasticism, heavily
tinted by Brahmanical ideology. But the meaning that the
artist must be pure of heart and self-disciplined, active and
efficient in work and a responsible member of the society or
community to which he belongs, is perfectly clear. He
should be one who could help the healthy functioning of
a social order by the production of useful articles and is
not an eccentric individual who lives as a parasite on society
with the sole purpose of producing works for aesthetic
pleasure alone.

The technique of mental visualisation in art through the
physical act of externalisation is akin to the psycho-physical
ritual of *yoga* which forms in Indian philosophical thought
the practical basis for working out abstract truths, and

22. From a Tamil *silpasastra* translated by Kearns, *Indian Antiquary*,
Vol. V. 1876.

 ibid., from Grunwedel, *Mythologie des Budhismus*, p. 192
 Also. "The artist is subject, in the sphere of his art, to a kind of
asceticism, which may require heroic sacrifices. He must be funda-
mentally in the direct line as regards the end of his art, forever on his
guard not only against the vulgar attractions of easy execution and
success, and against the slightest relaxation of his interior effort, for
habits diminish, if unexercised and ever so much more by any careless
exercise not proportionate to their intensity. The artist must suffer
sleepless nights purify himself without ceasing, voluntarily abandon
fertile places for barren places, full of insecurity. In a certain sphere
and from a particular point of view, in the sphere of making and
from the point of view of the good of the work, he must be humble
and magnanimous, prudent, upright, strong, temperate, simple,
pure, ingenious. All these virtues which the saints possess simpli-
citer, purely and simply and in the line of the sovereign good,
must inform the artist, *secundum quid*, in a certain relation, in a line
apart, extra-human if not inhuman. So he easily assumes the tone
of a moralist when speaking on virtue to preserve. We shelter an
angel whom we never cease to offend. We ought to be the guardians
of that angel. Shelter your virtue carefully......." (Maritain, *Art
and Scholasticism*, tr. J.F. Scanlan, Charles Scribner's and Sons, New
York, 1943.

thereby making intellectual awareness into a living realisation. Art like *yoga* consequently became a method and process rather than an attainment, the emphasis being laid not on the quality of the finished work as an end in itself but on the working out of that end according to a disciplined method.

In modern times, A.K. Coomaraswamy and Rabindranath Tagore interpreted the traditional Indian position in the light of modern theories and showed the rationale of accepting the point of view that art is a total human activity. Both maintain the position that the primary function of art is self-development or in Upanishadic terms *atma-sanskriti*. Thereby they returned to the basic Upanishadic position wherein beauty is experienced as an integral part of reality and the function of art is the transformation of the human personality from a lower to a higher order. While A.K. Coomaraswamy emphasised the approach similar to that held by the Christian scholastics which makes art akin to human intelligence, Rabindranath Tagore like the devotees (*bhaktas*) of India, stressed the deeply emotional aspect of art. The two approaches are distinct but as we have stated, not irreconcilable. They appear simultaneously in Indian aesthetic theories, the stress being at times on one aspect, at others on the other. The overall aim of Indian aesthetics nonetheless remains predominantly metaphysical wherein the conflict between sense and contemplation, between feeling and form or experience and knowledge is resolved.

ONE

The Aesthetic Experience

THE STARTING point of any theory of aesthetics is the recognition of a distinct aesthetic state which is of a different kind of mental and emotional activity present in what is called aesthetic experience. The exact nature of this distinction depends largely on the type of theory developed, but generally among other distinguishing characteristics it is marked by most aestheticians by a non-practical and non-cognitive aim described in such terms as "away from life" "disinterested", "impersonal", "detached" and so on. These negative attitudes do succeed in drawing attention to the basic problem, namely, the existence of a separate aesthetic mode, but they generally fail to take into account its distinctive nature.

The question is : is the aesthetic mode actually and fundamentally a kind of experience which is different from others, and if so, what is it that characterises this difference? Evidently, it will not do to take refuge behind such blanket terms as Clive Bells' unique "aesthetic emotion"[1] and explain all aesthetic experience in terms of it, nor to assign it as Kant does, to a special faculty of mind which is distinct from the practical sphere of the will, and from the intellectual sphere of the understanding and is concerned only with the sphere of feeling.[2] If a case must be made out for the

1. Clive Bell, *Art*, Chatto and Windus, 1914, p. 28.
2. *Critique of Judgement*, Tr. by Meredith, Clarendon Press, Oxford, 1964, p. 15.

existence of a separate aesthetic state, as indeed it must be, if aesthetics is to claim a value of its own, the exact nature of this state must positively be specified, whereby the distinction becomes substantially real and does not remain one of terminology alone.

The whole problem dissolves into whether a different set of terms such as "aesthetic emotion" or "disinterested pleasure" is in fact being applied to an experience, which is, substantially similar to other experiences but which is different only in degree or in the connections between their constituents or, whether the nature of the aesthetic as against the practical and the cognitive, demands a mode of thinking, willing, and feeling, qualitatively and intrinsically different from the other states.

According to Indian theory aesthetics is not only confined to that limited branch of study which deals with the appreciation of art-works and the problems arising therefrom, but is the delineation of an entire realm of enquiry within which all ordinary experiences, including those which arise from pure art activity, become aesthetic, the aesthetic state being not a specific mental faculty, emotion or attitude, but a composite state of consciousness wherein perception, feeling and understanding gain new dimensions. In Indian thought, the aesthetic mode is an experience of the whole man and not of a part of him. Taken in this very wide sense, a mathematician can in the course of his study gain the aesthetic perspective, as also the moralist or the craftsman. The peculiarity of the aesthetic state is not consequently in terms of that which isolates it from other experiences but that which elevates it to a different level. The experience of beauty does not concern the feeling of pleasure alone, no matter how impersonal, disinterested or detached this might be, but that which, with the realisation of truth and goodness, belongs to the intuitive consciousness, a state of being which is unified, homogeneous (*ekaghana*) marked by a total absence of discursive and relational elements and

is thus not available to the rational mode of thinking or knowing.[3]

The aesthetic consciousness thus comes about through a complete identity of the knowing subject with the aesthetic object, giving rise thereby to a pure experience of this, here and now, filtered of all extraneous influences and ingredients. Works of art due to their emphasis on the creation of vital and essential form, are a direct means to this experience. They are, however, only one of the many ways by which it can be attained. The aesthetic state contains the experience provided by works of art, but art is not the only means of evoking it.

The above view forms the basis of medieval Indian aesthetic thought and is best understood in the background of its overall metaphysics, particularly that of the Saiva philosophy.[4]

In Western idealistic thought, reason is the sole instrument of truth, and experience as a form of knowledge is valid only for the empirical order. The shortcomings of reason, as a means of uniting the individual with reality, were felt

3. *Ekaghana* literally means 'closely dense,' 'compact, that which is uniform and without obstacles'.

4. Saivism is one of the important religious systems in India, being proto-historic in origin. In its Kashmiri version it flourished around the tenth and eleventh century A.D. There are two systems of the Saiva doctrine, the Saiva Sidhanta and the Saivism of Kashmir. It is to the latter, of which Abhinavagupta was one of the well-known exponents, that we are referring. The central theme of this system as given in *Pratyabhijna*, one of its main texts, is that 'Shiva, the only reality of the universe, is infinite consciousness. He is the subject as well as the object, the experiencer as well as the experienced (*spandakarika*). "As the consciousness on which all this resultant world is established, whence it issues, is free in its nature, it cannot be restricted anywhere. As it moves in the differentiated states of waking, sleeping etc., identifying itself with them, it never falls from its true nature as the knower" (S. Radhakrishnan, *Indian Philosophy*, Vol. II, p. 732).

The world is created through the power (*sakti*) inherent in the Supreme Consciousness and all the forms manifested thereof are due to this energy. Saivism is essentially a monistic doctrine, influenced greatly by the philosophy of Advaita Vedanta.

by Kant who clearly showed its limitations to penetrate the
essence of Being. Noumena, unapproachable and remote,
was according to him forever inaccessible to the knowledge
and experience of man.

Indian idealist thinkers however, have never disassociat-
ed abstract speculation from a concrete realisation of its
metaphysical structure which they translate into living
reality. This position, at once metaphysical and psycholo-
gical, leads them to conceive of reality as consciousness,
and everything which is around us, as resting in the last
analysis on the Self.[5] The self is known not only through
the pure light of knowledge (*prakasa*) but can be contacted
directly in the essence of our innermost being (*vimarsa*). In
other words, reality is approached not by reflective reason
alone, but also through pure experience, the two being iden-
tical in the ultimate awareness, which is in the manner of
a realisation (*jnana*) and which has, its very essence, the
beatitude of ecstasy (*ananda*).[6]

Aesthetic experience is a modality of this unbounded
consciousness, characterised by the immersion of the subject
in the aesthetic object to the exclusion of everything else.[7]
It momentarily interrupts every day experience, presenting
itself as a compact, autonomous area of consciousness, un-
affected by elements of phenomenal existence.[8]

While the aesthetic experience is akin to the religious
state, it being referred to in traditional texts as the twin

5. Raniero Gnoli, *The Aesthetic Experience according to Abhinavagupta*,
 Roma, 1956, p. XXII.

6. K.C. Pandey, *Comparative Aesthetics*, Vol. I, The Chowkhamba
 Sanskrit Series, Benares, 1950, p. 82.

 "Admission of *vimarsa* or self-consciousness in the Absolute by
 the Saiva is the point of distinction between the Saiva and the Vedan-
 tic conception of Ultimate Reality. The latter holds that the *Brahman*
 is *santa* i.e., without any activity.... it is self-shining and not self-
 conscious.... The Saiva maintains that the Absolute is not only self-
 shining but also self-conscious."

7. *ibid.*

8. *ibid.*, p. XXII.

brother of the experience of Brahman,[9] there is yet a difference between the two. The subject in the aesthetic state while transmuting the occurrences and feelings of everyday life, remains ever conscious of them whereas the mystic state marks the complete disappearance of all polarity, and the contents of everyday life are transcended. The difference here is one of degree, not one of *kind*. Within the horizon of the aesthetic consciousness the empirical and rational order of things (*samsara*) is not eliminated as it would be in the religious state, but transfigured. This transfiguration effects the mysterious conversion of pain into pleasure, of sadness into delight, of mobility and inquietude into rest and the fulfilment of desires.[10]

To return to the question posed earlier, "Is the aesthetic mode actually a kind of experience different from other experiences?" It seems clear from what has just been said that there is a distinct aesthetic mode, distinct in its constitution and status, not merely in its function and method. In other words, the experience provided by art works is not different from other experiences only as shaving in the morning might be said to be different from working out a mathematical equation, but in a substantial way. The aesthetic experience though composed of the same material as ordinary states, breaks away in the intuitive moment from its empirical base and becomes momentarily a new and different kind of experience.

This view as developed by the Indian theorists rests on a number of assumptions which the modern philosopher may be tempted to challenge.

9. The following is Visvanatha's famous definition of the aesthetic experience given in his *Sahityadarpana*. It is similar to the conception
 of Abhinavagupta and his predecessor Bhatta Nayaka. "*Rasa* is tasted
 by the qualified person. It is tasted by virtue of the emergence of
 satva. It is made up of full Intelligence, Beatitude and Self-Luminosity. It is void of contact with any other knowable thing twin
 brother to the tasting of *Brahman*. It is animated by a *chamatkara*
 of non-ordinary nature. It is tasted as if it were our very being in
 indivisibility." (Gnoli, op. cit., p. 54 note 3)

10. Gnoli, op cit.,

The first assumption is that the aesthetic state is a thing *sui generis* different from the ordinary state of mind. It might be asked: what is implied by attributing uniqueness to the aesthetic mode? Is it not a dogmatic assumption, postulated in order to give status and value to an experience different from others only in degree?

Let us examine some of the views that are frequently put forward for the existence of a distinct aesthetic experience. Richards, for instance, advances the following arguments.[11]

(a) It may be held that there is a kind of unique mental element which enters into aesthetic experience, an element which does not enter into other experiences and which is the "differentia" between them. As Clive Bell maintains, there is the existence of a unique "aesthetic emotion" as the differentia. But the presence of such an inexplicable entity as he points out has no place in modern psychology. If we take empathy as being such an entity, we find that it enters into innumerable other experiences as well as the aesthetic experience.

(b) Another view which is commonly held is that the aesthetic state is qualitatively of "the same stuff" as the others but is of a special form, the special form being described in terms of impersonality, disinterestedness, distance, subjective universality etc. This form, Richards shows however, is sometimes no more than a consequence of the incidence of experience, a condition or an effect of communication. Moreover, disinterestedness and impersonality are attitudes which are shared by the scientist, and distance can also be used as a moral principle. Hence they are not unique to the aesthetic state.

The rejection of these and similar views in favour of a distinct aesthetic state however, should not lead to the conclusion that no particular province can be assigned to the aesthetic experience, it being, as Richards concludes, closely similar to other experiences, at best a further development, a finer organisation of them, and not in the least a new and different kind of thing. It only suggests that the approach

11. I.A. Richards, *Principles of Literary Criticism*, Routledge and Kegan Paul, London, 1963, p. 15.

to the problem is wrong and consequently these views go against the very case they hope to support.

When the Indian theorists hold that the aesthetic experience is different in kind from others they do not assume the existence of an ultimate aesthetic value or any other-ingredient which, added to ordinary experience, gives it the qualitative difference. Nor do they support their arguments by such general statements as: "Aesthetics is a unique activity since it is pursued without an end" or "aesthetics is intrinsic perception" or "art is intuition". These statements may be perfectly correct but are beside the point, since they do not further the case for a distinct aesthetic mode.

The aesthetic state as a thing "apart" must be shown to be opposed fundamentally to other experiences. The *alaukika* state of the Indian aestheticians is unique inasmuch as it is presented as a unitive, homogeneous experience within which the subject merges his identity. It is characterised by a state of compactness which is felt as beatitude. Within this state of self-sufficiency the self does not feel the need for anything other than itself. This type of beatitude cannot be enjoyed in practical life where things external to the subject are always desired. These break the unity of the aesthetic experience with their presence. The point of difference between the aesthetic and other states, lies in the fact that the former is an end in itself, undisrupted by any objective factors whereas in the latter the subject always presupposes an object. The distinction of subject and object which is present in all ordinary experience is obliterated in the aesthetic experience. Such an identification is not only never achieved in everyday life but is within the cognitive framework impossible. Discursive knowledge which forms the basis of our practical and logical state, is always formulated by a subject as against an object. A unified experience consequently marks a definite break with the world; it appears in the horizon like a new entity totally unlike the states of consciousness with which we are familiar.

It might be asked: in what way is such an experience different from an emotive one? Does not the diffusion of the subject and the object take place in every emotional

articulation? There is a fundamental distinction between the two apparently similar states. An emotional reaction is a sensuous org anic experience within which the ego predominates while an aesthetic response is a mental and spiritual reaction, a supersensuous experience within which the ego is transcended. It is a manner of experiencing emotion without ego even as *a priori* knowledge is intuitive insight gained prior to rational categories. It is in the full realisation of the self, the self taken not as a limited narrow empirical ego but as the ultimate unbounded consciousness, when there is a full participation of the subject within the aesthetic object, that the magical conversion of pain into pleasure takes place.

This extraordinary power of transmuting sadness into pleasure may be called the unique element, the *differentia* which belongs to the aesthetic experience which makes it a different *kind* of experience from others. The sudden transformation of pain into pleasure is not a miraculous phenomena but is the result of the individual consciousness finding its identity within the larger whole of the universal consciousness. This concept which is fundamental to Saiva metaphysics[12] forms also the basis of traditional Indian aesthetics.

Accepting then as our basic postulate, the existence of a distinct aesthetic mode, let us now try to analyse the chief characteristics of this experience and the factors which cause it to be provoked. The point is whether there is some factor or group of factors present in the object, such as a specific combination of lines and forms, sound and movement, which causes this particular kind of experience, and no other, to be provoked, or is it due to a certain mental outlook within the subject which brings it about. Clive

12. "The intimate essence of consciousness or the 'I' according to the Saiva, is beatitude. The absence of beatitude and suffering are due to a need, privation or desire for something separate from the self. Beatitude is the absence of this desire, the resting in oneself to the exclusion of everything else. The 'I' contains all things, everything that exists arises from its unconfined liberty. It cannot be the seat of any deprivation and can desire nothing but itself. Aesthetic experience is the tasting of one's own consciousness and, therefore, of one's own essential beatitude." Gnoli, op. cit., p. 87, note 2.

Bell, attributed it to an objective quality within the object itself which he called "significant form."[13] For Vernon Lee the psychological condition of empathy is the chief characteristic of this experience.[14] Some aestheticians identify it with an intrinsic perception,[15] and others[16] hold that it is essentially a kind of outlook, which permits us to see things from their reverse side, from the side which is not usually presented. It is an experience detached from the occurrences of daily life.

From the Indian standpoint, the aesthetic experience cannot be characterised in terms of any one factor, such as disinterestedness, empathy or the presence of "significant form" within the object. It can be provoked by any one of these conditions or by all of them in combination. But the experience itself, as already pointed out, must be a composite, unified state of consciousness, and there is no universal law, subjective or objective, whereby it can be known positively as to how and when it arises; at best one can stipulate the conditions which makes it most easily available. Chief among these conditions is the cultivation of an intrinsic perception. Such a perception is the result of *dhyana*[17] which is nothing more than an intense concentration upon the inherent qualities of the object, given in and for itself, without relation to any situation, event or thing beyond the object. Such an intrinsic perception is not peculiar to the aesthetic experience; it may accompany certain other activities such as the moral, scientific and religious. Its chief

13. Clive Bell, *Art*, Chatto and Windus, London, 1914, p. 36.
14. Vernon Lee, *The Beautiful*, Cambridge University Press, 1913.
15. D.W. Gotshalk, *Art and the Social Order*, Dover Publications Inc. New York, 1962, p. 4.
16. Edward Bullough, "Psychical Distance as a Factor in Art and an Aesthetic Principle" in *British Journal of Psychology*, V., 1912, pp. 87-98.
17. *Dhyana* is a cultivated state of contemplation wherein the mind is not allowed to wander. In normal life ideas come and go and concentration is usually brief. Through *dhyana* the mind is deeply concentrated in an even current of thought and the full nature of the object is revealed. Religious dhyana culminates in *samadhi* (see, Radhakrishnan, *Indian Philosophy*, Vol. II, p. 359).

advantage is to prepare the mind for the reception of a pure experience, which is generally not vouchsafed to us in the normal course of activity. Such a perception, drawing the mind away from its usual concerns, prevents it from taking interest in anything other than the object, object-field or situation which confronts it, and effects a complete detachment of the mind from its habitual patterns of thought and from the intruding demand of the individual's own self-interest. An attitude of detachment must clearly be understood to be a pre-requisite for the gaining of a pure experience and cultivated in the manner of a mental-discipline only. Taken as an end in itself and sought for its own sake, detachment can lead to the passive condition of indifference, a kind of world-negating attitude which is totally the opposite of the positive and affirmative aesthetic state of mind. Detachment by itself may, one can argue, lead to an isolation of the individual from society; in the field of art it may engender a devitalisation, and in the area of morality a dehumanisation.

Detached from all disturbing influences and intently concentrated on the aesthetic object the perceiver experiences an intense joy that has been characterised as having almost the same quality of joy that arises out of the realisation (tasting) of the Absolute (*Brahman*). Being essentially an experiential state (*anubhava*) its description defies verbal definition but the absolute joy which arises from an intrinsic awareness of the object is fundamentally opposed to the hedonistic concept of pleasure. Not being the result of any materialistic cause, nor due to the assertion of the objective individual ego, it is a kind of joy, wherein the adverse and passive reactions of ordinary pleasure are not suffered. It is an intensely active process resulting in a state of heightened emotion which has its effect on the bodily processes of the perceiver effecting a kind of purgation or psycho-physical healing. The term, nearest to aesthetic in Sanskrit is *rasa* borrowed from the ayurvedic *sastras*[18] which among its

18. *Ayurveda* is the ancient Indian science of medicine.

many connotations, implies a juice or bodily fluid.

The aesthetic experience, as a state of disinterested joy, is allied to the realm of intuitive knowledge (*jnana*) wherein the object is perceived, known and enjoyed in its concrete particular. Intuitive knowledge is a state of pure contemplation, characterized by a total absence of conceptual thought, wherein things are not recognised, classified, distinguished and analysed, nor are they related to desires and purposes. One ceases for a while to consider the where, the when, the why, and what for, of things and identifies one's entire being simply and solely with the *what*. The state of intuition is not an absence of knowledge, but a knowledge through "being" rather than through "reasoning". The subject "knows" the object, through a process of identification, by becoming none other than the object itself.[19]

According to Indian thought, the whole realm of intuitive knowledge wherein the aesthetic also partakes, belongs to the highest order of human consciousness, transcending the empirical and phenomenal states of existence. Yet it is important to emphasise that it is not an esoteric state but one which is accessible, even familiar to the common man. The aesthetic experience can and does occur at various levels and in varying degrees; it is a temporary state in which most normal persons probably enter many times even if only for brief moments. Those who do not, are nonetheless potentially able to do so. It is likely that all of us may not have felt the impact of the experience in its most intense form, a form with which only true artists are familiar, but nevertheless it is latently not beyond one's capacities to do so.

It might further be asked, whether the aesthetic

19. In Indian thought intuition transcends the domain of the intellect; it is a form of spiritual insight revealing those aspects of reality which defy reason. It is direct knowledge or immediate insight. The term intuition used in the context of Indian thought is quite different from its usage in modern philosophy as it implies a different and higher level of awareness, and that man has the faculty of transcending the intellectual sphere. Substantially, however, particularly in the context of aesthetics, it signifies the full illumination of the given object to the exclusion of all else.

experience is a positive one, and if so, what value does it have
for human life? For, indeed, if it does not contribute to the
growth and development of human consciousness it becomes
as meaningless as an illusion, hallucination or mere play
activity.

The aesthetic experience in its transcendence of ego, in-
tellectual categories, personal pleasure, pain doubt, hesita-
tion and all the other mental elements which disrupt its
compact self-sufficiency, is a liberating experience. It frees
the human consciousness from the limitations of mental inhi-
bitions, passive or blind passions, and consequently, as Aris-
totle maintained with regard to the value of tragedy, it exer-
cises a healing effect, leaving the individual spiritually
soothed and refreshed.

The value of aesthetics is not in the area of factual know-
ledge for it adds nothing to our storehouse of facts, nor do
we gain any propositional insight or a metaphysical truth
concerning reality. An aesthetic contact leaves us no more
knowledgeable than before but definitely more illumined
and elevated. It adds depth and dimension to experience,
consequently its value lies in the area of intrinsic awareness;
its insight is indeed a perceptual insight. This is not the
case with non-aesthetic states such as dreams and hallucina-
tions, no matter how vivid and realistic they may appear to
be.

Inasmuch as the aesthetic experience expands percep-
tion and awareness adding depth and dimension to superfi-
cial experiences, and widening the horizons of the person-
ality, its value for human beings is equal to if not more than
that of scientific knowledge. But, it might be asked: can
the experience be acquired and cultivated in the same way
as knowledge? Yes, it can. Contrary to the common belief
that it is an inspired state of mind, arising forth uncalled
and at least expected moments and taking possession of its
victim in a kind of divine madness, the aesthetic is a cons-
ciously cultivated state. Indeed, if it were incapable of be-
ing acquired its value would be purely negative. The culti-
vation of aesthetic sensibility is the cultivation of mind, will
and feeling. These faculties properly trained, directed and

organised permit us to enjoy actively the very same emotion which would normally oppress, and to relish it fully without suffering the distasteful reactions which generally accompany blind, undirected ego-centric feeling.

Aesthetic experience by the enrichment of sensibility brings about a greater and more highly organised state of mind and thereby helps positively in the evolution of the human consciousness. The cultivation of sensibility, aesthetic or religious, has been systematically worked out in Indian life and thought.

No doubt, an aesthetic response as such cannot be taught and no amount of instruction can help to bring it about. The aesthetic sensibility is a matter of the intuitive and not of the ratiocinative faculty. A man who is otherwise devoid of this faculty cannot be taught how to respond aesthetically to a certain situation, but he can be taught how to cultivate it. In other words, while we cannot force an actual aesthetic experience upon an otherwise unresponsive subject, the special attitude which helps to engender it can be acquired. The aesthetic attitude puts us in a peculiar relationship with the world; we are on the one hand completely disassociated from the situation, on the other we are so completely identified with it that we are able to immerse ourselves within it to the exclusion of all else. This act of simultaneous disassociation (from its existential properties) and identification (with its essential nature) is not something which comes naturally or unbidden but is the result of a disciplined and conscious effort. The aesthetic experience is instructive only in this sense.

Accepting as our basic postulate the existence of a distinct aesthetic mode we must now apply this solution to art theory and enquire into the nature of the relationship that exists between the art process and aesthetic experience. How does a concrete work of art such as a poem or dramatic performance, for instance, give rise to the singularly subjective aesthetic delight? Is there any principle by which a work of art can be distinguished, whereby it gives rise, invariably and necessarily, to the aesthetic emotion? This is the problem which we shall now proceed to discuss.

TWO

'Rasa' as a Principle in Art and Aesthetics

THE NATURE of the aesthetic emotion, the unique and extra-ordinary (*alaukika*) delight afforded by works of art, and through the experience of which a transmutation takes place, is summed up by Bharata in the concept of *rasa*; *rasa* is indeed considered by all later Indian aestheticians to be the essence and soul of art.[1] Though Bharata originally used the term in connection with drama and poetry it was later carried over to the other forms and genres of art as well.[2]

In its normal usage, as has already been remarked, *rasa* means a kind of juice or sap and signifies literally the flavour one gets from tasting this liquid. It is a term borrowed from Indian medical science, even as Aristotle borrowed the term *katharsis* used in relation to tragedy, from Greek medical science. It had also a metaphysical connotation as when in the *Upanishads* it is taken to be akin to spiritual delight (*ananda*)[3] Generally it refers to the essence of a thing

1. "No composition can proceed without *rasa*", Bharata in the *Natyasastra*.

 "There is no poetry without *rasa*", Abhinavagupta in *Dhvanyalokalocana* 2.3. "The meaning of poetry is *rasa*", *Abhinavabharati*, 7.1.

 "A composition touched with *rasa* is poetry", (Vishvanatha) in *Sahityadarpana* 1.3.

2. K. Krishnamoorthy, "Traditional Indian Aesthetics in Theory and Practice", in *Indian Aesthetics and Art Activity*, Transactions, Vol. 2, Indian Institute of Advanced Study, Simla, 1968, p. 43.

3. According to Abhinavagupta, *rasa* or aesthetic experience at the highest level is nothing but *ananda* or spiritual delight. This conception of rasa is in perfect harmony with the assertion made in the *Taittiriya* Upanishad (II.7) "*Raso vai sah*".

and this was the meaning carried over into aesthetics and art. As an aesthetic experience, *rasa* refers not to the mere organic pleasure derived from tasting (*asvadana*) but signifies a kind of impersonal and objectified pleasure. When the term *rasa* is used as a factor in art it refers to the much needed criteria of the beautiful as against the merely agreeable and pleasant.

This concept, therefore, became in Indian aesthetics and art-theory the most comprehensive principle signifying the art-process in all its phases, the creative, the created and the appreciative. An object which does not contain *rasa* cannot be classed in the category of an art work, and no experience without it can be called aesthetic. Through this concept also was sought to be explained the well-known antinomies of art as met with in such polarised terms as "realistic and idealistic", "personal and impersonal", "subjective and objective", "emotional and intellectual", "sensual and spiritual", "practical and contemplative", for instance. In other words, *rasa* as a quality of the art object and of the aesthetic consciousness could synthesise both aspects and offer a point of reconciliation.

What exactly is the nature of *rasa*? Bharata, in a well-known aphorism, explains it as being that quality which arises out of (a) the combined factors presented objectively by an art-work, the images etc., in a drama, for instance, in the form of dramatic characters, costumes, scenery, movement and action, and (b) those subjective reactions which these factors evoke in the spectator. He said "out of the determinants, (*vibhava*) consequents, (*anubhava*) and transitory mental states (*vyabhicharin*) the birth of *rasa* takes place."[4] In order to understand fully the implication of this aphorism it is necessary to analyse the above terms. Determinants (*vibhava*) refer to what in ordinary life would be the causes for arousing certain emotions, that is actual physical media. In real life these would be termed simply natural causes; in a work of art however since they are part of an artificially

4. Raniero Gnoli, *The Aesthetic Experience According to Abhinavagupta*, Roma, 1956, p. 29.

created situation, they are referred to as determinants in order to mark the difference from natural causes. Similarly, consequents (*anubhava*) refer to the physical reactions caused by the determinants as they appear within the virtual context of the art situation, and transitory mental states (*vyabhicharin*) refer to the mental states which accompany such causes and responses. All three combine to evoke a kind of feeling which is not real, due to its not being aroused through real causes but is sufficiently like a feeling to warrant its being categorised within the same class.

This special kind of feeling is termed *rasa*, in order to distinguish it specifically from emotion as an ordinary physical phenomena referred to as *bhava*. The two have an intimate connection yet they are generically different.

The main points of this theory are (a) *rasa* is not feeling in the ordinary sense, though it is constituted of the same material; it bears all the characteristics of actual feeling, yet it is free from its adverse effects; consequently it is essentially and invariably pleasurable, (b) *rasa* is achieved when everyday feelings (*bhava*) are purified on the one hand through the medium of art, and on the other hand through the imaginative faculty of the spectator. The 'union' of the determinants, consequents and transitory mental states that Bharata refers to, is the delicate balance of these forces, their subtle interaction within the aesthetic situation. The precise nature of this balance is indeterminable, the weight being sometimes on the side of the objective factors as they are presented in the art work, and sometimes on the side of subjective consciousness. No one factor by itself is sufficient, all must combine to give birth to *rasa* (c) The emergence of *rasa* becomes possible because the aesthetic situation is unlike a real life situation, being an imaginative creation; yet ideal as it is it has a reality akin to that of everyday life, (d) *Rasa* is not a mental construct in the manner of a logical entity, nor is it the idea of feeling nor the generic essence of one; it is feeling proper though of a different kind, (e) *Rasa* cannot be explained in terms of imagination and illusion; it is the result of a purification, but not in the sense of a religious or moral purification; it is simply and purely an

aesthetic quality, significant only within the aesthetic context; it has a logic, law and life of its own, a reality which is different but in no way lesser than that of real life.

Let us now analyse some of the implications contained in the above statements. The first is that aesthetic feeling is aroused in quite the same way as ordinary feeling, requiring the very same causes etc. for its provocation, except that it appears in a situation which does not bear upon us directly. This fact helps to take the weight off our feelings as they would be in everyday life, and to enjoy actively, what in normal circumstances might be suffered passively. The problem this position raises, is : "Can we have an all pleasurable feeling, indeed can we refer to a response that is devoid of the usual motivation causes, as feeling at all ?" In real life, for instance, a passion or feeling is undergone due to the self being affected by certain causes, such as the sight of a lion which arouses terror or the thought of one's beloved which arouses love. Whether the cause is direct and immediate, the situation created by the art-work however presents not an actual but an apparent situation. The lion though real enough for sight and hearing is part of an unreal situation. We know that it cannot affect us; consequently it cannot arouse any feeling equivalent to that undergone in real life. The point the *rasa* theorists stress is that even though the aesthetic emotion is part of an art situation, and in a sense removed from the domain of practical life, it is constituted of the same material as the emotion of ordinary life, and thereby establishes a direct connection with the spectator. Bharata for this reason considers only those elemental human feelings which he calls *sthayibhava*[5] to be able to provide the material for the aesthetic emotion and not any passing whim or fancy. Feeling is aroused in the spectator despite the unrealistic situation created by the art work, because he possesses inherently those feelings and emotions which are being depicted; he has at some time or another undergone them fully, with all the good or bad effects which generally accompany such

5. *ibid.*, p. 29, note 2.

feelings. Consequently during the aesthetic moment, he can revive those feelings; this revival is not in the form of a memory, but an actual living experience. This process the Indian aestheticians distinguish from mere empathy by using the term *udbodhana* or *carvana*[6] which means literally, 'recollection' or 'rumination' figuratively, a living through. The point of difference between empathy and *udbodhana* lies in the latter being an independent first-hand experience. Empathy is primarily a feeling dependent on the object and hence it is subject to all the adverse effects or otherwise which the object may undergo.[7] Since it is not independent it is suffered passively as are all ordinary feelings, and is controlled by the circumstances given in the objective situation. The aesthetic response on the other hand, uses the objective situation provided by the art object as a stimulus only, in order to create an experience with an existence and dimension of its own. The fact that the artistic context removes us from the reality of the situation, does not prevent the arousal of emotion, as indeed all the causes and other factors are present, it only removes from the emotion that aspect which connects it directly with the egoistical self, the limited narrow self which is concerned only with its own preservation, and which thereby cannot expand fully and enjoy the depth and dimensions of pure experience.

The spectator's distance from real life helps to filter the emotion from all its adverse reactions, the pain, suffering, etc., which accompany even pleasurable emotions like love. It must be pointed out that it is not the actual physical and temporal distance alone that makes this detachment on the part of the spectator possible but his mental attitude as well.[8] The spectator must be able to disengage himself

6. K.C. Pandey, *Comparative Aesthetics*, Vol. I, The Chowkhamba Sanskrit Series, Benares, 1950, p. 152.

7. Cf. H.S. Langfeld, "Empathy", in *The Problem of Aesthetics*, edited by Eliseo Vivas and M. Krieger, Holt, Rinehart and Winston, New York, 1966.

8. Cf. Edward Bullough, *Psychical Distance as a Factor in Art and an Aesthetic Principle*, ibid.

from the events and situations presented within the art work, not by reminding himself that these are not real but by refusing to let them affect his personality. He disengages himself not from the whole situation but only from that part of it which impinges upon his practical self and which in normal life would lead to action. The difference between his everyday response and the aesthetic response is simply this; that whereas in the former case the emotions aroused have a motivating force, in the latter they only colour the consciousness,[9] lending to it every other ingredient but that which leads to action. Ordinary emotion (*bhava*) consequently devoid of its troublesome element (the element which makes it personal to a particular self) and loosing its self-isolation and limitation, converts itself into generalised emotion.

Rasa, as Abhinavagupta pointed out, is nothing but the transformation of ordinary emotion (*bhava*) into this generalised emotion. The process is a kind of purgation but not the same as the *katharsis* of Greek tragedy. The idea of a medical cure was by no means unknown to Bharata; indeed as we have already pointed out *rasa* had among other meanings also a medical connotation,[10] but the simple heightening of emotion and that too, of pity and fear alone was not considered to be the sufficient cause of transforming ordinary emotion into aesthetic emotion. *Rasa*, does not imply simply the expulsion of the disturbing effect, namely, pain, which enters into pity and fear when aroused by real objects, and which when eliminated brings about a

9. "Transitory Mental Movements follow one another, threaded on the thread of the Permanent Mental State. They rise and set an infinity of times. They may be compared to beads of crystal, glass, mica, topaz, emerald, sapphire etc., continuously changing their position, threaded, so as to be set rather far apart, on a red or dark blue thread. These beads on such a thread leave no trace of themselves, but all the same they nourish the ornamental composition animated by this thread". Gnoli, op. cit., p. 92.

10. *Caraka-Samhita, Sutra-sthanam*, 26.12, and *Susruta-Samhita, Sutra-sthaham*, 14,2, referred to by Pravas Jivan Chaudhary—*Studies in Aesthetics*, Rabindra Bharati, 1964, p. 184.

certain quietude in the spectator's mind; it is a more positive concept entailing an actual reliving on a different plane. *Rasa*, does not involve, like the tragic *katharsis*, the idea of an emotional relief alone, even though this is one of its effects,[11] but it involves primarily the idea of a purification which leads to a state of exaltation and ecstasy.[12] This purification results from the removal of pain, disquiet and unrest which generally accompany the egoistical and self-seeking element.

Within the ideal world of art, the ego is disengaged from the events and actions that occur. Hence the individual does not suffer the effects of the reactions, either painful or agreeable, that generally accompany such events. The elimination of these disturbing effects results automatically in a perfectly peaceful state of mind (*shanta*) which forms the basis of an ecstatic condition.

This process also accounts for the fact that in a work of art, events which would normally arouse feelings of horror, disgust, fear and sorrow are actually enjoyed. For instance, the tragic drama wherein intensely pathetic emotions are aroused, is actually the source of great aesthetic delight. Likewise the portrayal of a love sequence enacted on the stage, which might in actual life arouse feelings of disgust, envy or indifference, evokes only the most pleasurable feelings.

This is because, in a sense the feelings and emotions aroused by a work of art, do not belong personally to any one. They belong neither to the actor, nor to the spectator. They have, so to speak, no location in actual time and

11. S.H. Butcher, *Aristotle's Theory of Poetry and Fine Art*, Indian Edition, Delhi, 1967, p. 245. "Bernays maintained that *katharsis* here is a medical metaphor, 'purgation' and denotes a pathological effect on the soul analogous to the effect of medicine on the body. The thought as he interpreted it, may be expressed thus. Tragedy excites the emotions of pity and fear-kindred emotions that are in the breasts of all men—and by the act of excitation affords a pleasurable relief."
12. Pravas Jivan Chaudhary, *Studies in Aesthetics* op. cit., Rabindra Bharati, Calcutta, 1964, p. 186. Also *Abhinavabharati* vi., 34 and *Dhyanyalokalocana* 1. 4-5. Also, see *Kavya Prakasa* 4.28.

space. The feelings and emotions evoked by the work of
art are therefore transpersonal. In the dramatic enactment
events occur as they do in actual life. A lion chases a man
who runs away in fear, or Rama is banished to the forest
for fourteen years and leaves amid weeping and wailing,
while his father dies of grief, yet the spectator enjoys these
scenes. Why? Is it because he feels himself at a safe dis-
tance and derives a morbid satisfaction from other people's
misfortunes? Certainly not. It is because the painful
emotions in fact belong to no one. The spectator knows
it and willingly accepts the fact. Untroubled by the
responses which naturally accompany actual emotions, he
can allow himself to enter the make-believe world of art
with an unsullied and untroubled mind. Here he can rise
above conflicts, doubts and anxieties. At the same time
because the elemental emotions which are portrayed are
inherently in him as well, he can identify himself with the
heroine and yet not weep over her infidelity. She does
not belong to the same time and space as he does. She
belongs to a world which he can enter and leave at will. He
does not question this state of affairs, he accepts it and
willingly suspends logic and rational belief.

This aspect of the aesthetic attitude is best understood
by the purity of a child's mind. A child finds very little
difficulty in transcending his ego and entering immediately
into the most fantastic make-believe world. He does not
question the topsyturvy state of affairs in Alice's Wonder-
land nor does he ask whether it is biologically possible for
men as tiny as the Lilliputians to exist. When he is in their
world he does not apply to it the standards of real life.

In this process of purifying emotion and bringing it to a
new plane of existence, withdrawal from the affections of the
self is only the first stage. The rasa experience, metaphori-
cally described as an actual tasting, is simultaneously an
act of self-identification. Herein the aesthetic situation is
not simply contemplated but 'lived through'. The term
sadharanikarana, taken by Abhinavagupta to be the essence of
rasa implies this two-fold process of impersonalisation and
identification, of objectification and a subjective experience.

The term "generalisation" by which it is usually rendered, does not however adequately convey that aspect of its meaning whereby it is understood to be an inward realisation, an actual participation within the aesthetic situation.[13]

The question arises however as to how an actual tasting or a first hand experience can be possible, and what exactly is it that is tasted? Indeed it might be reasonably asked, how can the artist convey a private phenomenon such as an emotion at all so that the audience experiences it in exactly the same way as the artist does? Because that which is in fact tasted, is not an objective phenomenon as presented by the work of art, but the actual feelings of the spectator himself which it evokes. The taste of the art-work is due to a recollection and a revival of one's own experience as afforded by the art medium and which one "re-lives" in tranquillity. This experience is one with which most creative artists are familiar. Wordsworth expressed it in the memorable words "Poetry is the spontaneous overflow of powerful feelings, it takes its origin from emotion recollected in tranquillity; the emotion is contemplated till, by a species of re-action tranquillity disappears, and an emotion, kindred to that which was before the subject of contemplation, is gradually produced and does itself actually exist in the mind."[14] Indian aestheticians refer to this process by the usages of two terms *udbodhana*, which literally means 're-collection', and *carvana* which signifies 'rumination', a going over or re-living of the recollected material. *Carvana* implies a process on the mental plane similar to the chewing of the cud on the physical plane, a process of bringing up food which animals employ in order to enjoy it at ease well after the actual meal is over. Abhinavagupta makes *rasa* synonymous with this re-living; he says, it is nothing but

13. Gnoli, op. cit., p. 51 "Generality (*sadharanya*) is thus a state of self-identification with the imagined situation, devoid of any practical interest and, from this point of view, of any relation whatsoever, with the limited self and as it were impersonal."

14. George Whalley, *Poetic Process*, Routledge and Kegan Paul Ltd., London, 1953, p. 66.

"the tasting of one's consciousness."[15] Accordingly, the art object is only in the nature of a stimulus which helps to bring forth that which is already present in the spectator, and to evoke from the rich depths of his emotional and imaginative life, a mood corresponding to that of the artist. The art-work sets aflame the imagination of a sensitive spectator even as a spark kindles dry wood.[16] The experience, the emotions, feelings, memories, images, all are present within the spectator, the artist only awakens them through an appropriate presentation. Identification takes place when the spectator finds within his depth of experience, a response which is identical to that created by the artist; it is not so much a feeling *with* him but a feeling identical *to* his. Many aestheticians describe this feeling of identity as a capacity for intense sympathy for a 'withness' with the object. The *rasa* theorists take it to be more than this; for them the subject does not only feel *with* the object but *becomes* the object. In the first kind of experience the object is distinct from the subject, in the second kind the subject-object relation may be said to be transcended. The emotion here is experienced virtually by itself without reference to the object. It is pure experience for and in itself. This kind of experience is the highest and can only occur when the aesthetic evocation is an emotional one, for emotions alone provide the material for a subjective re-living which transcends the objective order. It is to this purest experience that the concept of *rasa* is applied, and it is here that the demand for a total identification is made wherein

15. Gnoli, op. cit., p.87 "In this connexion all *rasas* are dominated by pleasure; for the essence of light, closely dense (*ekaghana*) light, consisting of the tasting of one's own consciousness is beatitude."

16. *ibid.*, p. 65. *Natya-sastra* VII, V.10. "The faculty of self-identification with the events represented demands that the mirror of the mind should be made completely clear, by means of repeated acquaintance with the practice of poetry. The possessed of heart, those who possess the consent of their own hearts, are those who have this faculty. For it has been said : "the tasting of that which finds the consent of the heart arouses the *rasa*. The body is pervaded by it as dry wood by the fire."

the subject realises himself as none other than the object. All aesthetic experience however does not reach this level as all art-works are not necessarily built around emotional themes. The artist may, for instance, choose themes which centre around things, relate events, delineate action or simply describe pictorially the scenes from nature or life. Such themes never reach the heights of experience as do those which are based on emotion, but nonetheless they can and are often used as aesthetic material.[17]

Bharata pays a great deal of attention to the type of material best suited for the creation of *rasa*, and the most appropriate method for its effective presentation. He finally concludes that the eight elemental emotions alone of delight (*rati*), laughter (*hasa*) sorrow (*shoka*), anger (*krodha*), heroism utsaha) fear (*bhaya*) disgust (*jugupsa*) and astonishment (*vismaya*) are really suited for this purpose. Later he admitted a ninth feeling namely, serenity (*shanta*). These emotions being stable (*sthayi*) and universal, find a ready correspondence in human experience and permit an easy identification. An elaboration of this theory further suggests a distinction between the three levels of emotions, personal, objective or generalised, and aesthetic; this is not explicitly stated by the *rasa* theorists but implicitly implied in their analysis.

Modern aestheticians sometimes draw this distinction by referring to the private phenomena of an individual psychic state passively undergone and suffered as "emotion" and the generalised presentiment of an emotional state felt by no one in particular, yet finding its correspondence in the experience of mankind in general as "feeling". This is the "feeling" which aestheticians declare as belonging impersonally to works of art and which constitute the basic principle in artistic experience.[18] These terms are used with no rigid distinction, it being a matter of choice entirely as to which term is preferred for which function. Sometimes the term

17. Cf. M. Hiriyana. *Art Experience*, Mysore 1954, p. 6 : "The poet may aim at communicating a fact (*vastu*) or transferring an imaginative (*alamkara*) or an emotional mood (*rasa*)."
18. George Whalley, op. cit., pp. 66-67.

'emotion' itself is used for both functions, the distinction, being made by the use of such adjectives as 'private and objectified' 'subjective and universalised' etc. In any case the distinction centres around only two emotional levels, namely, the psychological which includes the intensely private affections of the subject, and the aesthetic which signifies broadly an objectified emotion. The psychological level of emotional experience is rendered clearly in Indian aesthetics by the general term *bhava*. In their analysis of the aesthetic emotion however, they were led further to distinguish between two levels: (a) the concept of an objectified emotion presented as an element of the art-work, for instance, the dramatic performance, poem etc. (b) its subsequent conversion into a universal emotion actually existing in the mind. The former they term *sthayibhava* which signifies a permanent and sustained feeling as against a transitory and fleeting one (*asthayibhava*). The *sthayibhava* alone, as we have seen, is considered as suitable aesthetic material and it alone in combination with other elements, gives rise to the final aesthetic emotion. This highest emotional level is *rasa* and is clearly distinguished from emotion in its ordinary connotation and from emotion appearing as an 'element' in the art-work.

The almost imperceptible distinction between *sthayibhava* and *rasa* which has been so clearly analysed by Abhinavagupta was missed by his predecessors. For them, *rasa* is only another name for *sthayibhava* when it is heightened to an intense degree. This analysis however, misses entirely the point of the *rasa* theory which emphasises the complete disassociation of the aesthetic feeling from ordinary emotion, as it is experienced in everyday life. Another point of view which held sway for sometime before Abhinavagupta is the theory that *rasa* is the imitation of a real emotion. This view also misses the point of the *rasa* theorists inasmuch as it does not take account of the authenticity and actuality of the experience which emerges as a reality on a different plane.

Rasa as the essence of the aesthetic experience, has a life and dimension of its own, it is not a reflection of real

emotion but a different kind of emotion. When *rasa* is taken
to be the essence of the art work, it is not perceived like a
quality, as preciousness is in diamonds or hardness in rocks,
but it is that totality of effect which arises from the object
as a whole. Bharata compares it to the individual flavour
which emerges from a dish made of many ingredients, each
contributing its own taste, yet permitting a unique flavour
to arise unlike any which belongs to the ingredients sepa-
rately.[19] And these ingredients in the aesthetic situation
belong, as we have seen, not to the object alone nor to the
subject alone; a combination of both forces are necessary
for the aesthetic emotion to take birth; it depends on a sub-
tle balance of interacting elements. For the creation of *rasa*
it is indeed extremely important to maintain this balance.
Sometimes *rasa* does not arise in an otherwise perfect situa-
tion due to a fault in the subject, such as the subject being
too preoccupied with personal affairs, and thereby not be-
ing able to slip into the aesthetic attitude. Several examples
can be given; for instance, a man who has had an unfortu-
nate love affair too recently may find it difficult to enjoy an
otherwise excellent performance based on the theme of love
and jealousy as his own case is too close a reminder of an
event he would much rather forget. *Rasa* which accompa-
nies necessarily a detached state of mind would elude such
a spectator. Indian aestheticians take account of certain
recurring "obstacles" which generally stand in the way of
aesthetic enjoyment and recommend their removal by little
techniques which the artist may employ. First, they clearly
recognise the aesthetic senses to be only two, that of sight,
and hearing, considering the "obstacle" too great to be over-
come in the case of touch, smell and taste which are far too
closely related to the physical self to be generalised. De-
tachment from these therefore, becomes almost impossible.

The several "techniques" of drama and dance enunciated
by Bharata is his *Natyasastra*, particularly those which relate
to the preliminaries, are all designed to instruct the produ-
cer as to how to bring about *rasa* in his spectators, lest an

19. Gnoli; op. cit., p. 31 note 2.

otherwise excellent performance is lost due to an unrespon-
siveness on their part. Unlike modern dramatists who
leave the audience largely to its own resources, the Indian
producer sought to woo and court the audience through the
extensive employment of the extraneous devices of (*nandi,
vidushaka*), dance, music setting, costumes and other side-
effects in order to establish the closest link with it. For
instance, in mythological and legendary themes, *rasa* is
likely to be dispelled due to doubt and incredulity creeping
into the mind of the audience regarding the authenticity of
the characters playing as gods and demons. In order to
overcome this difficulty the Indian theatre used the mask and
elaborate headwear, so that the mortality of the actor is
submerged and his immortality appears credulous.

In order to overcome the difficulty of an unresponsive
attitude, it is enjoined in the *Natyasastra* that certain mental
disciplines should be undertaken. Sometimes however, *rasa*
is not created in a perfectly responsive audience due to an
inherent fault in the structure of the art-work, the most
common fault being the lack of unity, not of time and event
alone, but of emotion and mood. The mind, it is held, can
rarely find stability and rest when confronted by an assort-
ment of quick changing moods. By this it is not meant
that a single mood or emotion must suffice for the entire
performance, but that a single dominant emotion *sthayibhava*
that which is stable enough to be heightened and transform-
ed to *rasa* must unite the performance, supported by those
others which help and enhances it. A number of moods
can appear in a single performance provided they help to
create a unified effect. As Bharata says, "When in the
midst of diversity of psychic states all transfigured by the
imagination, there is one master passion unifying all of
them like a thread that is to be regarded as the ruling senti-
ment of a work of art, the rest are but momentary
(*asthayi*)."[20]

The entire *Natyasastra* is a compendium of rules in-
structing the artist in the best methods of creating *rasa* in

20. K.C. Pandey, op. cit., p. 53.

an art-work and in the audience. The methods emphasise the maintaining of a subtle balance between the type of work produced and the state of mind evoked in the audience. The indispensable "preliminaries" are not part of the drama however, and a warning is issued against overdoing them, lest the audience gets impatient and becomes unresponsive instead. The principles of drama are clearly recognised to be "methods" alone, which by themselves are not sufficient to produce *rasa*; they can at best prepare the way by creating an atmosphere, whereby the spectator is suitably "distanced" from the art-work being neither too close to it psychically, nor too far removed. A somewhat similar idea has been developed by Edward Bullough in modern times in his concept of psychical distance as a factor in art and a principle of aesthetics. Bullough seeks to explain aesthetic appreciation and production solely through this concept, which he understands as not an actual spatial or temporal distance but a mental or psychical distance which must be present between the self and its affections in order to make aesthetic experience possible. By the self's affections he means anything which affects our being, bodily or spiritually, as for example, sensation, perception, emotional state or idea. Usually it amounts to the same thing to say that the distance lies between our own self and such objects as are the sources or vehicle of such affections.

"The transformation by distance", says Bullough, "is produced in the first instance by putting the phenomenon so to speak, out of gear with our practical, actual self; by allowing it to stand outside the context of our personal needs and ends, in short, by looking at it 'objectively, as it has often been called, by permitting only such reactions on our part as emphasise the 'objective' feature of the experience, and by interpreting even our 'subjective' affections not as modes of our being but rather as characteristics of the phenomenon."[21] In reference to art appreciation, Bullough shows how distance is a variable factor dependent on two different sets of conditions affecting the degree of distance in any

21. Edward Bullough, op. cit., pp. 397, 398.

given case, namely, those offered by the object and those realised by the subject. "In short, distance may be said to be variable both according to the distancing power of the individual and according to the character of the object."[22]

Bullough's lucid analysis, admirable as it is in every way, suffers only in one respect; it takes account of only a single phase of the aesthetic experience, namely, that which requires a kind of mental adjustment. It is however, possible to have a perfect mental attitude; according to Bullough, this would come through "the utmost decrease of Distance without its disappearance," and still not experience aesthetic delight to the full.

The height of aesthetic ecstasy takes place when the self, released from the burden of its affections, finds a complete identity within the aesthetic situation. The process of identification is not due to an attitude of mental distancing alone but due to a positive act of self projection. Bullough's theory does not take account of identification as an aesthetic principle, but only of distance. Identification according to him is the natural state of mind wherein the self is identified with what it feels. The introduction of distance alters this state of identity by filtering the relation between the self and its feelings of its personal character. In other words, all that is required in the aesthetic experience is a detached outlook, not the impersonal sort that takes place in science but one of a very special kind.

The *rasa* theory on the contrary, regards the process of identification as a separate and positive phase, consisting mainly of an expansion and enlargement of the self on a new plane of existence. The act of identity arises out of the capacity to detach oneself from passive and blind impulses, but it is consequently an independent state of mind, constituted no doubt of the ordinary emotional state but transforming this into a new and different kind of experience. The main point of difference lies in the fact that though the *rasa* theorists regard detachment or distancing to be a necessary stage in the development of the aesthetic

5. *ibid.*, p. 402.

experience, they do not consider it to be the sole cause for bringing about the actual relish or taste which is the essence of the aesthetic enjoyment. The act of identification calls for a capacity to feel strongly, a capacity for sympathy, and for an immediate recognition of a corresponding emotion from the depths of one's own experience.

Artists, and likewise sensitive spectators, are no doubt persons with powerful emotions but for a sympathetic identification the capacity for imaginative recreation (*bhavana*) is equally important. Identification implies an urge for a "withness" with the object, for a becoming one with it; this urge is in the form of a drive which seeks constantly to transcend the self to a plane of existence where the unhampered consciousness can dilate on and enjoy an uninterrupted delight. The capacity to feel *with* the object and *as* the object, gives the artist an insight into the essence, life and form of things, an insight into the inner nature which when vividly apprehended becomes the very soul of art. This move for self-identification is rather the antithesis of detachment for it is a simultaneous plunging into reality, a losing and discovering the real self in a real world and not the contemplation of an uninvolved spectator.

The traditional Indian aestheticians have been very careful in taking account of 'identification' as an aesthetic principle and analysing it as the factor in an art-work which rise to the singular aesthetic delight. *Rasa* sums it up in one gives word.

THREE

The Nature of Art

In our discourse so far we have constantly been using words or phrases like "art" "the work of art" "the art activity" etc. which assumes an understanding on the part of the reader, of what is meant by such words and phrases. We must therefore now deal with these and find out as explicitly as possible as to what is meant when we refer to an activity as "artistic" and an art-fact, object or composition as a "work of art".

The attempt to clarify the nature of art has invariably presented innumerable difficulties. The demand for a definition of art assumes the existence of some common characteristic present in all the arts, despite their differences in form and content, irrespective of whether the art form is dance, music, painting or poetry, pottery or architecture, for instance. The range of art works, however, is so vast that the very possibility of a definition seems to be inadmissible. What common set of characteristics, for instance, is there between a totem pole, carved, by a Red Indian craftsman and a sculptured work such as Rodin's *Thinker* or between a group dance of a primitive tribe and the highly sophisticated rendering of the classical Indian *Bharatnatyam* as performed by a modern dancer? Even art forms created within the same temporal or cultural milieu do not apparently share common characteristics. Each art due to the peculiar medium it uses—colour, sound, movement and so on—has its own unique technique and form which cannot be applied

to the other. The art of *batik* painting[1] is subject to laws
quite distinct from portrait painting in oils, or landscape
painting in water colours. Sometimes the attempt to provide
a common ground for all the diverse arts, leads to the inter-
pretation of one art in terms of the other, as when we speak
of the music of poetry, or the poetry of architecture, or the
architectonic effects of a painting, or sculpture, as dramatic.
Confusion can only result in such sweeping comparisons.
Even well-known terms like 'music' and 'painting' and
'architecture' are likely to be more misleading than useful;
for, popular music produced for entertainment is a different
sort of composition from the poetic beauty of the *ghazal*[2] or
the rigid purity of the *raga*.[3] And there is all the difference
in the world, between a Kangra miniature[4] and an Ajanta
fresco[5] between the Taj Mahal and a country cottage.

Is art then to be defined in terms of some criterion by

1. A technique of wax painting on cloth.
2. The *ghazal* is the typical art form which combines lighter variations
 of classical Indian music with Persian poetry. Coming into existence
 with the Muslim urban cultural impact on Indian classical music it is
 even today one of the most popular forms of music prevalent in North
 India, mainly Uttar Pradesh, of which Lucknow and Delhi are the
 traditional focal centres.
3. A musical composition made up of a fixed number of notes. It forms
 the basis of the Indian musical system and is based on a harmonious
 permutation of notes. Theoretically thousands of *ragas* are possible,
 but in fact, only a hundred or so are in use, of which approximately
 thirty are mastered by an artist. The Indian system requires strict
 conformity to the structure of the *raga*, within the framework of
 which alone the musician can improvise. The *ragas* are classified
 according to moods and seasons.
4. A miniature painting typical of the *Kangra* school of art which
 flourished in the Western Himalayas during the 18th and 19th century.
 It is noted for its fine line drawing and vivid colour schemes. Indian
 miniatures were painted for the pleasure of the royalty and the nobi-
 lity who collected them in an album. The themes are generally
 religious but are very much secular in spirit.
5. The famous murals painted on a massive scale on the walls of the
 Ajanta caves in the district of Aurangabad in Maharashtra. These
 date back to the second through to the sixth century A.D., and like
 classical Indian sculpture are informed by the quality of inner move-
 ment, vitality and grace.

means of which its sphere can be distinctly marked from other human activities? It is interesting to note that till modern times, neither in the West nor in India any sharp distinction was made between what is today called the "fine arts" and "applied arts" or the common handicrafts. Plato included everything from the simplest skills of shoemaking and carpentry to the aesthetic arts of music, drama and poetry to the highest and most difficult art of life itself,[6] under the term "art".

What then is meant by art? Taken in its widest and most general sense, that is the sense in which it includes both shoe-making and living, it means nothing more than employment of human energy and skill towards the production of an organised result.[7] In this broad sense inasmuch as it signi-fies an ordering of nature's chaotic elements it is not very different in its aim from science, logic and moral activity, for in all these fields the effort is primarily towards greater organisation whether it be of materials, facts, thoughts or actions.[8] In the early stages of human development, when men were occupied wholly with the task of disciplining the physical forces around them, there was in fact no speci-fic difference between these three fields of human activity

6. It is significant that the Greeks used the same word *techne* which means literally technical or skilful in regard to the arts and crafts. The artist (craftsman or artisan) was a professional *technite*. *Techne* was applied broadly to the profession of the builder, potter, carpenter, etc., as well as the poet, painter and musician. The Greeks also considered rhetoric as *techne* art. Cf. *Plato's Theory of Art*, by Rupert C. Lodge, Routledge and Kegan Paul Ltd., London, 1953.

7. Cf. Irwin Edman., *Arts and the Man*. W.W. Norton, New York, 1939, p. 351. "So far from having to do merely with statues, pictures, and symphonies, art is the name for that whole process of intelligence by which life, understanding its own conditions, turns them to the most interesting, or exquisite."

Also, cf. A.K. Coomarswamy, *Transformation of Nature in Art*, Dover Publications, New York, p. 35. "Neither the Society nor the specific arts can be rationally enjoyed without a recognition of the metaphysical principles to which they are thus related, for things can be enjoyed only in proportion to their intelligibility, speaking, that is, humanly and not merely functionally."

8. Irwin Edman, op. cit., p. 36.

which was a coordinated effort towards the mastery and control of the environment.

In India till modern times no distinction was made between the artist and the craftsman both of whom were expected to follow a routine in mental concentration and method similar to the saint and the man of intellect. The goal of all these was to realise a clarity of vision, which revealing the inner law of outward things, would result automatically in right doing, thinking and making, whether it concerned the living of life as a whole or simply the construction of a single article such as a stone image, a chariot or an arrow, for instance. This all inclusive sense of art emphasises its basic character which is simply to arrange and order through the force of the individual's physical, mental and emotional energy, disorganised elements, and to project them externally as the outer aspect of an inner principle.

This point of view typical of the Indian approach presupposes that the impulse to art springs from the same source as the impulse to science and religion, namely from the intuitive faculty of man. It also implies that art is not the product of an accidental, incidental or superfluous activity of man, like the impulse to play which he pursues only when his appetitive wants are satisfied; nor is it the result of any extra-mental faculty, or of a mysterious sixth sense. In other words, it is not a functional, symptomatic or mystic tendency but belongs to the essential part of his being, the same part from which springs his rationality, and morality.

Ultimately knowledge is one, it is only in the manner of its employment and the purpose for which it is used that the consequent distinctions of art, science and morality arise. Hence in Indian thought even as in Plato, art and morality are considered identical since both concern ultimately a perfection of "doing" and tap the same source from which epistemological truth too, derives. Art, being not different in its aim and source from the highest in man forms a part of his spiritual activity; in Indian traditional terminology one would say that it is the *satvik* element as

brought into human activity through the *rajasik*.[9]

This broad connotation of art emphasises no doubt its contemplative aspect, it should be added however that according to the Indian point of view the idea of art covers not only the moment of intuition but also execution. The methods of *yoga* employed mainly for religious purposes, apply equally to the practise of art and *yoga* is also dexterity in action; *yogah karmasu kausalam* so says the Bhagavad Gita (11, 50).[10]

In the application of art to human ends, the term also acquired a narrower usage wherein it came to signify the production of those concrete works which embody in visible and tangible form the artist's intuition. In traditional Indian society, these works covered a wide range from the simplest article made for human use to the most elaborate.

When the term "art" is employed in its narrower sense wherein it signifies the production of particular objects

9. Knowing is an act of identity, wherein the subjective and objective are not irreconcilable categories, but merge in a common unity. Reality (*satya*) like truth and beauty subsists where the intelligible and sensible meet. Coomaraswamy elaborates this point which, he thinks, is implied "in the scholastic definition of truth as *adequatio rei et intellectus* and is also what is meant by Aristotle's identity of the soul with what it knows." In this connection he quotes St. Thomas "...knowledge comes about in so far as the object known is within the knower." (Sum. Theol. m. 1, Q. 59, A. 2) and argues that what St. Thomas said was in 'radical contradiction to the conception of knowledge and being as independent acts, which point of view is only logically and not immediately valid." (A.K. Coomaraswamy, *Transformation of Nature in Art*, op. cit., p. 11) It is from this single source that the impulse to science and philosophy also springs; the mode of art, completes it.

10. No distinction was made as is done today between the fine and grosser arts. What today goes under the category of skill, craft, applied art etc. was included in their comprehensive term *silpa*, under which was listed eighteen or more professional arts. Personal accomplishments were termed *kala* in which all the performing arts along with cookery and the performance of magic was included. (Cf. A.K. Coomaraswamy, *Transformation of Nature in Art* , p. 7). The status of the particular art depended not on the extent to which it was free from practical ends but on the status of the artist. (*ibid.*, p. 180) Crafts were considered equally worthy of embodying the artistic quality).

according to a specific method, it can be defined more con-
cisely in terms of this method. This method is distinct, and
quite different from those which are employed in the pur-
suit of other human activities such as the scientific and
practical.

In the first place it must be noted that the function of art
is not to state facts, nor to analyse concepts, nor to act as
an aid to prayer or meditation. Its function is chiefly that
of providing a complete integrated area, a self-sufficient
region within which the artist works with the main purpose
of creating outward forms in perfect conformity with an in-
ner vision. The process which ends in a work of art is at
once a discovery and an act of self-realisation. George
Whalley expresses a similar idea when he says in his analy-
sis of the poetic process, "a work of art is as it were an
extension of some valuable experience of the artist....not
simply in mental, spiritual, or experimental terms, but also
in physical. The artist's experience has somehow been em-
bodied, incarnated, made physical while still preserving its
spiritual identity.[11]

The work fails to imbibe the artistic quality if the inner
vision is confused, vague and influenced by considerations
other than those which pertain to the perfection of its form,
or if the externalisation is not skilfully executed. A perfect
clarity of vision does not make the externalising process an
automatic one, as the medium has problems peculiar to it-
self and these can only be mastered by a studied application
of technique. A skilful reproduction without the support
of an inner vision is not art any more than a pure mental
vision, without its physical embodiment.

Artistic truth is attained when the outward embodiment
conforms to the inner visualisation, hence the work of art is
not simple expression but the complex process of discovery
and self-discovery. The inward intuition and the outer form
working in a close and intimate relationship go to form an
organic structure, the outward aspect forming the manifested

11. George Whalley, *Poetic Process*, Routledge and Kegan Paul, London,
 1953, p. 12.

body, so to speak, of the intuitive soul.

While the ultimate purpose of art in general is that of creating forms in perfect conformity to an inner vision, specific works of art can be made, indeed have been and should be made for numerous social and utilitarian ends as well. Artists have been known to compose for name, fame, and wealth among other reasons, to say nothing of amusement, political motives and instruction.[12]

The fact that works have been made for a specific purpose does not make them lesser works of art. However, it is when such external considerations distort the mental vision and affect the formal principles of construction that the artistic content diminishes. It is quite possible that art can be made for a specific purpose and yet maintain its integrity of form. If this were not so, architecture which always serves an end would never be considered to be art. Some of the world's greatest masterpieces like Michelangelo's massive mural covering the roof of the Sistine Chapel in Rome, would never have come into existence if the artist had not been compelled to work according to the dictates of a Pope whose only motive was to find a decoration grand enough to bring honour to his name as a patron of arts. The images of gods and religious icons which abound in Indian art, have all been made for the purpose of providing an adequate symbol to the devotee and act as aids to his meditation. There is no contradiction here with the earlier statement that the purpose of art is to form a self-sufficient system and not to serve any external ends. All that is meant is that while the process of art is pure it can be applied to an end. The application does not effect the process. Music, dance and drama in the East have been for centuries a hieratic art,[13] and it is well-known that Shakespeare wrote his plays mainly for the purpose of

12. Mammata; *Kavya Prakasa*, 2, p. 6. "The purpose of a play like that of all poetry is to please and to instruct in a pleasing manner in the style of a loving wife", quoted in *The Indian Theatre*, by G.B. Gupta, Motilal Banarsidass, Benares 1954, p. 14.

13. Cf. A.K. Coomaraswamy and G.K. Duggirala, *The Mirror of Gesture*, Munshiram Manohar Lal, New Delhi, 1970, p. 8.

earning a livelihood. If art be the employment of man's creative energy towards the production of objects according to an inner law, the most important quality of an art-work is the clarity with which the artist's intuition has been embodied within. The fact that a work has been made for a functional purpose should not by itself be sufficient to debar it from being an art work.

Similarly the fact that an object has been made with no end in view (if this is possible, for every human activity pre-supposes some end) is not sufficient to make it an art work if it lacks the necessary qualities of energy, clarity and vigour which should have gone into its making. In other words, a musical composition, an abstract design, or a fantasia in colour or sound is not art just by virtue of its being non-functional. If it were so every naive and superficial effort to construct things for pure perceptual value would have to be taken for art. It is often argued that artefacts once constructed for use, such as the stone implements and pottery belonging to a remote civilisation, "become" works of art through the passage of time when however they lose their functional purpose.[14] Such a view gives to art an accidental quality not belonging to it. A work of art is that alone, which reflects the individual conscious vision of the artist; whether it serves a specific purpose or not is incidental to its value. The question of ends is in any case a relative one. All human activity presupposes some end and every medium imposes its natural limitations upon the artist who is never really free. A musical piece with tones, sounds, harmonies and rhythms has its own laws to which the composer must conform even as the craftsman conforms to the functional requirement of the article he makes. The degree of conformity may vary but in every case, whether it be in the so-called "fine arts" or in "handicraft", the end is ever present; art lies in the manner in which the end is worked out and absorbed into the whole pattern. The manner must be such so as not to

14. Cf. D.W. Gotshalk, *Art and the Social Order*, Dover Publications Inc. New York, 1962, p. 6.

intrude and disrupt the autonomy of the art process but to fit into it inorganically. It is this conformity of ends and means, form and content, which is referred to as the integrity of the art work, and which must be maintained at all costs. Poetry has its own rules of composition, as painting has its techniques, and though these devices of art creation can be and are transcended from time to time, the artist always works within a framework, even though it be self-imposed. In the strict sense of the term a totally *free* artist is not an artist at all. In fact the fixed forms within which the artist is often required to work and the limitations of the medium are a challenge to his creative powers.[15] He endeavours to put the stamp of his individuality upon the physical matter of the art work in such a manner that its very uniqueness reflects a universal quality. The artist projects his idea through the difficult medium of matter, organising and arranging it in a manner most suitable to the successful projection of his vision.

Art is not an end in itself but a process, a way of making things. The art object is the working out of this process which can apply equally to handicraft as to fine art, to religious icons as to secular images.[16]

15. Cf. Anand K. Coomaraswamy and G.K. Duggirala, op. cit., p. 3. "Indian acting or dancing—the same word, *natya* covers both ideas—is thus a deliberate art. Nothing is left to chance; the actor no more yields to the impulse of the moment in gesture than in the spoken word......... It is the action, not the actor which is essential to dramatic art...... The more deeply we penetrate the technique of any typical Oriental art, the more we find that what appears to be individual, impuslive, and 'natural' is actually long-inherited, well-considered and well-bred."

16. The difference between craft and art lies not in the fact that the latter is a pure form of art and the former mixed, but in the purpose for which each is made.

For instance Indian classical music is highly technical. The structure of the *raga*, is based on scientific principles without an understanding of which no proper and adequate appreciation is possible. But, despite these fixed rules (*bandish*) of the *raga* the performer can express great individuality in its rendering. The true artist in India is not necessarily the one who composes a new melody,

(*Contd.*)

The question now arises as to what does the artist express. Evidently he does not express abstract ideas and concepts which are best done through the logical syntax of language, but directly experienced laws and principles through concrete imagery. Art is not the expression of intellectual knowledge but of intuitive knowledge. The artists process does for subjective experiences what logic does for ideas; it clarifies and brings them to an objective plane. In doing so it helps to release the individual from the passive condition of suffering his own private feeling (*tamas*) and brings him through a state of intense activity (*rajas*) to that of calm clarity (*satva*)[17] The final stage is reached when the art intuition has been physically externalised and the artist can contemplate it as does an aesthete.

Art thus acquaints us with the experiential side of life, bringing the subjective life of man to an objective plane. This does not mean as some recent exponents of the cognitive theory of art, like Susanne Langer have tried to make out, that our feelings are thereby rationally understood and that art is merely a kind of knowing. All that we have just said means that the artistic feeling is experienced by itself in a generalised way, apart from the experience of the personalised emotion that produces it. Borrowing

(Contd.)

but the one who can express himself well within the prescribed musical form. In the West the composers like Beethoven, Bach, Mozart, Wagner are of far greater consequence than those who play their music In India the composers' names are practically unknown. The same principle holds in Indian classical dancing where new compositions and innovations are rare. The fixed form does not upset the Indian artist, rather it offers a challenge to him and helps him to achieve great depth of expression.

17. *Tamas, Rajas, Satva* are according to Samkhya metaphysics, the three intertwinable qualities of phenomenal nature, ever present in varying degrees. Pure *tamas* is the lowest limit of blind nature, and pure *satvik*, the highest point of clarity. These points are ideal conceptions only; existence implies an intermingling of all the three. In the human psyche, these three strands signify the development of the spirit.

a phrase from Susanne Langer, we can say justifiably that the experience is "abstracted" from the background of emotions of which it is composed.[18] Art, no doubt is also concerned with the perception of form as it is abstracted from its physical elements; we only wish to emphasise the fact that it deals primarily with experience, its intrinsic characteristic being not perceptual alone, but inclusive of feeling and awareness. At this level art develops ranges of sensibility and widens the dimensions of man's inner life.

If science is the formulation of thought, art is the transformation of feeling. This transformation is universal, inasmuch as it is within the capacity of all human beings to undergo it, yet every articulation is a unique experience

Art is not a mechanical reproduction but an individual process, produced at the cost of a tremendous personal effort. If the view of "craft as art" has fallen into disfavour now, it is mainly because there is tendency to mass produce objects and blindly repeat forms which have long since lost their vitality.

From the foregoing discussion we can see how difficult it is to provide a concise formula that will serve as a definition of art. Most of the brief definitions that are generally offered such as "art is intuition" or "art is disinterested pleasure" or "art is significant form" etc., fall short of being true definitions. For, while they cover one or another aspect of the art process, they fail to take into consideration many other aspects which are equally important.

Therefore, if at all we undertake the almost impossible task of defining art, it should be done in the broadest manner possible.

To define art simply as intuition as Benedetto Croce and the adherents of the Expressionists theory do, is to take an extremely one-sided view of the problem. Similarly to regard it merely as a form of manual dexterity as the Greeks did is also to misunderstand the total nature of the art

18. Langer uses the term "abstraction" in connection with visible form which she says is abstracted from the background of materials of which the art work is composed. *Feeling and Form*, pp. 49, 59.

activity. There is also a general tendency to call the prac-
titioner of any fine art, an artist. This sweeping definition
overlooks the fact that art is a special kind of activity
rather than the production of a special kind of result. As
James Cousins points out, "To be a practitioner of an art
is not necessarily to be an artist, any more than to practise
thinking is to be a philosopher, or to practise speech is to
be a poet."[19] It would perhaps be nearer the truth to call
an artist, "one who makes his craft a fine art". Ambiguous
as this definition is, it does draw attention to the basic
characteristic of art, that is, to its being essentially a means
and a process (whatever be the medium it uses) for the in-
dividual to gain greater dimensions of experience and per-
ception, such as cannot be gained through the means of
ordinary knowledge and activity.

As such we might define art as a kind of dexterity in
thought as well as in execution, a special mode of know-
ledge and a special method of execution which liberates and
transforms the artist from the ordinary to a unique and
higher level of experience. Understood in this way art is
a quality which belongs as much to the artist himself as it
does to the mode of knowledge and action he employs.

We have said that when the term art is used in its nar-
rower sense, it is taken to mean the production of concrete
objects which are called works of art. What are the quali-
ties that such works must possess in order to distinguish
them from ordinary products is the problem to which we
must now turn.

19. James Cousins, *The Faith of the Artist*, Adyar. 1941, p. 49.

FOUR

Truth, Reality and the Work of Art

FOR the traditional Indian artist a work of art[1] is the material concretisation of his intuitive vision, the externalised form assumed by his inner experience, the body in which his intuition is made real. Such an externalisation may be called *murti*[2] (image) which means in Sanskrit, literally, an embodiment, or *citra* which in an extended meaning, stands for 'painting', 'picture' but derivatively means an object that happens to be an externalisation of what was in the *chit* or consciousness.[3] In the case of the poetic and dramatic arts, the work of art goes under the names of

1. In India works of art may be either the artist's creation, the meditator's aid to contemplation or the craftsman's product. The line of distinction is not between art and craft as such but between works of artistic skill and technically produced objects. The former implies the employment of creative energy and thought, the latter implies reproduction and mechanical application of rules only. Accordingly an icon, or object of practical worth, such as a utensil or article of furniture etc. can be artistic and a painting or sculpture merely technical. The use of the terms, "work of art" and "art object" or "aesthetic object" in the above discussion however refers to those works only which imbibe the artistic quality, and since such objects are to be found more often in works of fine arts we shall for convenience, confine the discussion to such objects only.

2. Stella Kramrisch, *Indian Sculpture in the Philadelphia Museum of Art*, University of Pennsylvania, Philadelphia, 1960.

3. According to Budhaghosa, the Buddha is said to have held that a painting (*citta* which also included sculptures, bronzes and terracottas) was essentially the product of the functioning of the *citta* (mind, consciousness) "*cittam cittenaiva cintitam*".

nrtta (pure dance), *nrtya* *(abhinava*-dance), *natya* (dance-drama), *kavya* (poetry) *raga*, (musical composition) all of which follow a definite pattern of structure and maintain the strictest rules of aesthetic composition. Any radical deviation from the methods of artistic construction detracts from the art value of the work. This does not mean that deviations from prescribed rules by an artist are never permissible; it implies only that the formal structure of a work of art is as important an aspect as the moment of contemplation in which the artist visualises the entire work, and that an art object is the lawful manifestation of an inner experience; it is a concrete image.

In the case of sculpture, such images were made by craftsmen-artists for generally two purposes (a) worship (b) adornment of temples and public places. In the making of cult-images for worship, the primary aim of the craftsman was to adhere to the canonical prescriptions as faithfully as possible rather than to create an aesthetic form.[4] Such images equivalent to *yantras* or icons, were symbolic in the mathematical sense and were not, generally speaking, aesthetic objects. In non-iconic images however, used for purposes other than that of worship, the primary aim of the artist was to enlist the participation of the spectator in an experience of his created form. These images were constructed in a manner designed to express through their visual imagery the awareness of life as experienced immediately and directly, by the spectator.

The *murti* of aesthetic value, as against the icon (*pratima*) possesses foremost a quality of vitality and dynamism which communicates itself not through the symbolism of abstract meanings but through the vivid presentation of its own

4. In the *Sukranitisara*, Sukracharya states that the laws of image-making are mainly for images used for worship, whereas the spirit of beauty cannot be confined within any canon. "These Lakshmi, are not for thee, these laws that I lay down, these analyses of what an image should be, are for those images that are made to order for people who would worship them. Endless are these forms ! No *sastra* can define thee ! Nothing can appraise thee." (Tr. Mulk Raj Anand) *Hindu View of Art*, p. 77.

being. Such an image has the power wholly within itself to compel the response of the spectator in a perception of its own intrinsic aspect. The symbols and allegories employed within its structure merge into the entire composition presenting an undisrupted whole and do not point to any meaning lying beyond. A *murti* of aesthetic worth whatever may be the purpose for which it was made, is quite distinct from an icon, inasmuch as it impresses the spectator by the sheer force of its imagery. It is a powerful coherent structure, a unified entity embodying the inner movement of life, the flux and flow as experienced through its breath (*prana*) and sap (*rasa*).

According to Indian theory, knowing and experiencing are on three planes of references; they are of objects in their gross aspect (*sthula*), of objects on the subtle plane (*sukshma*) and of the transcendental spirit lying beyond. The art work does not represent nature's grosser forms but represents objects etc. on the subtle plane of existence. It is the representation of life beyond its surface aspect at the level where the spectator can directly participate with the essence of things.[5] As such the work of art does not imitate nature in her outward aspect representing her forms realistically, but aims at presenting the inner life movement which pervades the whole of nature and which is not evident to the external senses. Yet, even though the work of art is not a copy of nature, the artist draws his data from nature and presents his images in the familiar forms he sees around him. Trees, flowers, landscape, animals and human forms are used freely as motifs, but there is no attempt to represent them realistically. This anti-realistic nature of art is likely to suggest that the traditional Indian artist had an idealistic aim, whereby he tried to create forms nearer to his heart's desire. This was not so. The ideal of the Indian artist was not to create a finely proportioned human figure with flawless limbs and features such as the Greek figures of Apollo and Venus, but to convey the experience of an underlying dynamism. He merges human and animal shapes into each

5. Stella Kramrisch, *Indian Sculpture*, op. cit.

other in order to express the essential unity of man and nature.[6]

The *murti* according to conventional taste may not be pleasing to the eye; its defiance of physiological laws, may suggest even a lack of skill on the part of the artist. But it should be remembered that this defiance is deliberate. The Indian artist was required to be a skilful craftsman with full knowledge of his trade. If he distorted the human form it was evidently because he was not interested in the human body as a physiological phenomena, recognising clearly that the achievement of a perfect physique is the concern of the *yogi*. "The plastic quality of Indian sculpture is the created visual counterpart to an awareness of the body as a receptacle filled with the breath and the pulsations of life... it captures by its plastic quality the inner sensation of pulsating life, breathing its spirit to the tips of the fingers and into every movement and mien."[7]

It can indeed be said that the Indian artist fully realised that the essential quality of the art work lay not in the structural organisation of its surface elements or in their formal arrangement according to the principles of proportionate measurement and harmony, but in the creation of an empowered coherent image, successful to the extent to which it communicated an inner movement, an essential and dynamic living quality.

The same conclusion was reached by the later Sanskrit rhetoricians, when they eventually discovered that the poetic work in its totality was not equivalent to a combination of

6. "All Indian sculpture has an astonishing life-quality. The figures into which the Indian shrines and temples seem to blossom have a kind of vegetable rhythm and luxuriance. The stone has been made to symbolise a tropical exuberance in growth; the animation seems to spring from a force that lies behind the corporeal envelopes, a force that vitalises the animal and the vegetable world with one and the same life. The woman in the 'Two Lovers' on the Kailasanatha temple at Elora (eighth century) clings to the man like ivy to a tree; and we get this same universal rhythm in the Indian figures with several pairs of arms like the well-known bronze figures of Siva Dancing." *ibid.*, p. 151.

7. *ibid.*

its words, sounds, metaphors, and literay effects etc. but connoted something over and above it. The earliest theorists analyse the poem as a finished product, seeking to find its essence in the style and manner of its composition. For Bhamaha and Rudrata[8] the foremost exponents of the *alamkara* school,[9] the poem was a physical fact capable of being constructed scientifically, in the same way as an engineer constructed a bridge.[10] The only difference between a scientific work and an art work lay according to them, in the ornamentation with which the latter was embelished, this ornamentation (*alamkara*) consisting in the arrangement of words, the turn of a phrase, the construction of a metaphor, the use of a similie etc.[11] The art of poetry (including drama and music) became accordingly similar to any scientific study and the poet was considered to be a discoverer and classifier of literary figures. His artistic ability was judged by his technical ability to manipulate his material. These early aestheticians committed the error of emphasising the surface quality of art work to the exclusion of its inner substance.

The *riti*[12] school of thought which followed the *alamkara* tried to shift the emphasis from the purely perceptual surface qualities of the poem, to its formal qualities. To this end they compiled elaborate lists pertaining to those principles of artistic form, which could create the finest literary effects.

8. S.K. De, *Sanskrit Poetics as a Study of Aesthetic*, Oxford University Press, Bombay 1963, pp. 4, 23.
9. *ibid.*, p. 4. This earliest school of poetics, regarded "poetry as a more or less mechanical series of verbal devices in which a definite sense must prevail, and which must be diversified by means of prescribed tricks of phrasing, the so called figures of speech to which the name of 'ornament' (*alamkara*) is given".
10. *ibid.*
11. *ibid.*, pp. 4, 23, 82.
12. *ibid.*, p. 83. The term *riti* means literally style. S.K. De explains how "the history of poetic speculation (*alamkara sastra*) is commonly treated in terms of several schools....... The oldest is called simply the *alamkara* school from its preoccupation with the figures. The second of the schools is usually characterised as the riti, from the place of honour it gives to this stylistic idea."

Harmony, balance, melody, and style were studied for their own sake rather than as tools of the literary work. That the art work was an empowered image, pervading over and above the materials of which it was composed, was a fact which eluded them as it eluded their predecessors.

Anandvardhana in his theory of *dhvani* was the first to point to the nature of the poetic work as a substantial entity, as something other than the aesthetic surface and formal qualities of which it was composed. The materials used to create the literary work were its necessary constituents but in themselves did not constitute it. The poem was something other than the words and sense which composed it. It was a third non-physical entity, so to speak, the value of which lay not in its own physical existence, nor in the accuracy of its propositional statements but in its power to evoke a powerful dynamic effect which was informed by a living quality.

It should be noted that the problems of art cannot be completely separated from the aesthetic experience. And though an isolated discussion of the type we are engaged in at present seems to establish the possibility of a discourse about the object in isolation from the creative act and aesthetic response, it is in fact not possible. Unlike their predecessors, the questions raised by the *dhvani* theorists and by the *rasa* school of thought regarding the nature of the poetic image, presupposed at every point the observer. What the poem was taken to be, depended on the creative act and aesthetic experience; its traits were not analysed in isolation but took into account the observer, his senses and his sensitivity to these traits, Similarly, the concept of the work of art in the plastic and other arts was formulated in the context of the observers' qualities.

For instance the living quality with which the work of art was said to be imbibed and which made it appear to be an independent, self-sufficient entity was the result of a combination of elements, of which, the spectators' response was an essential aspect.

The question now arises as to what is meant by referring to "life" in a work of art. When reference is. made to the

"movement" and "life" in a work of art is it suggested that stone images literally breathe, eat and sleep like living creatures and the poems, or musical compositions move around like human beings ?[13]

The analogy of the art work to an organic entity is one of similarity only and not of identity. *Prana* the breath of life does not actually course through the limbs of the *murti*; this life carrying agent is only the core of the modelling which creates in effect a quality of life having a direct impact on the spectator. It is to signify this inseparable relation between the aesthetic enjoyment and the object which is enjoyed that the same word *rasa* is used. The connoisseur is *rasajna* or *rasika* i.e., one who enjoys *rasa*. Indeed the tasting of rasa (*rasasvada*) corresponds to the art of criticism.[14]

The art object is a living organism only in its created effect. It does not actually live and breathe but gives the illusion of life. It does not literally possess "feeling" as a quality but appears to do so. This illusion of pulsating vitality created within the art object is also the result of creative devices employed by the artist. The principle device is the creation of an integrated coherent system within which all the elements are functionally involved. As in natural systems the varied activities fit into an inter-related pattern, the distinct processes coinciding and complementing one another harmoniously, so also within the system of the art object all the individual elements relate naturally, the whole becoming a functional pattern.

The art object is like a natural organism inasmuch as its elements are not independent parts but like the organs within the body, inter-related centres of activity, each part involving the other in a necessary function. This point is exemplified in one of the basic devices employed by all artists, namely rhythm. Rhythm is not merely the appearance of an event in the periodic succession of time or space;

13. Susanne Langer, *Problems of Art*. Routledge and Kegan Paul, London, 1957, p. 45.
14. *ibid.*, Chapter VI.

it is primarily an involvement. The close of one event necessitates the other; for instance, the end of a movement in dancing is already the beginning of the next and the resounding end of a drum beat is the take off for the next. Our very heart beat and bodily processes are rhythmic.[15] No living organism is without its system of rhythm and the art work also presents rhythms within its body in order to give the illusion of life and in this sense alone imitates nature, the imitation being of the process and working of nature. The artist sees nature at work and depicts her, according to his feeling and understanding of her mode of operation. This is not a passive transcribing of nature as the eye sees but an active creative process involving the greatest artistic insight.

Where it is said that art made by man is an imitation of divine art, that is, of the art of nature (*manushya silpa devasilpanam anukritih*) all that is actually meant is what we have said above. It means that the art of man *follows* the art of nature, that is, follows natural laws. *Chanda* or rhythm is this law *par excellence*.

We have presumed, according to this theory that the art work has an objective status. It might, however, be asked: can it, as the form of a sensuous awareness, make any claim to truth and reality ? In what way can it communicate a private feeling, if indeed it does communicate at all ?

In answering the question of truth we must first know

15. Susanne Langer, *Problems of Art*, p. 51. Also *Rabindranath Tagore on Art and Aesthetics*, Orient Longmans, New Delhi, 1961, p. 48: "The world as an art is the play of the supreme person revelling in image-making. Try to find out the ingredients of the image—they elude you, they never reveal to you the eternal secret of appearance. In your effort to capture life as expressed in living tissue, you will find carbon, nitrogen and many other things utterly unlike life, but never life itself... For art is *maya*, it has no other explanation but that it seems to be what it is... All that we find in it is the rhythm through which it shows itself. Are rocks and minerals any better ? The fundamental distinction of gold from mercury lies merely in the difference of rhythm in their respective atomic constitution.... There you find behind the scene the artist, the magician of rhythm, who imparts an appearance of substance to the unsubstantial."

the sense in which this term is being employed. The art work does not correspond to empirical events or logical truth. While the artist does borrow his materials from the physical world he employs them in a totally unrealistic manner, maintaining an illusory correspondence to the emotional plane. Yet unless the spectator takes the illusion of art to be real in a manner other than that which appears in dreams or free-floating imagination, the theory upon which the present statements are based is invalidated.

In our attempt to define truth, we shall for convenience, refer to the two-fold definition suggested by James K. Feibleman, which is "a truth according to correspondence and coherence, the correspondence between propositions and the objects to which they refer and the coherence or consistency of parts in a whole respectively."[16]

It is clear that the type of truth that the art object has, is the one which maintains a coherence or consistency of parts in a whole. The work of art is a new entity, consisting of old parts; its validity lies in the selection and reassembling of the recognisable material in a manner in which the elements do not refer directly to themselves but point indirectly to values beyond. The essence of the art work lies in this indirect reference and in its capacity to conjure a new universe of reference, where the material elements do not draw attention to themselves but loose their identity within the larger coherent whole. The external body of the art object acts like a stimulus which creates an illusion transcending its physical being. The work exists in time and space but the illusion it generates transcends the physical categories.

Does this imply then that there are two art works, the vehicle and its appearance? The art object does not refer to something other than itself, as a proposition does to a concept or a symbol to a meaning. The illusion is the art object. The elements transform themselves so to speak before our very eyes. By a sudden change of attitude and

16. James K. Fiebleman, "Truth Value of Art" in *Journal of Aesthetics and Art Criticism*, Vol. XXIV, No. II, Summer 1966.

an altered mode of perception, we become aware of an imaginal whole which compels attention to itself by usurping the entire consciousness. The experience is similar but not the same as that of *Gestalt*. For instance, in all dramatic enactment which has not yet come "to life" we see the elements which go into its making, such as the actors, costumes, words, musical and lighting effects, as individual factors drawing attention to themselves independently. A little arrangement of the material through the employment of well-known creative devices whereby all the factors assume a new contextual relationship, and the work which was a moment ago an ordinary enactment presents itself suddenly to our perception as an artistic piece. The change is due to the suggestive values assumed by the factors in their involvement within the whole.

The truth of an art work then can be said to lie in

i) The coherence of the subtle value in a new universe of reference.

ii) The consistency with which these values are evoked, by which is meant the creation and use of symbols which issue naturally from the plastic flow of the media which are expressive in themselves and not dependent on conventional or linguistic meaning to make them explicit. In what way it is possible for art works to express without reference to conventional meanings, will be disussed in the following chapter.

In answering the question of reality we must know the sense in which this term can be applied to a work of art. It is clear that a work of art is not a physical substance, existing in real time and space. It does not belong to the solid world of facts exhibiting measurable characteristics as physical objects do.

The question then arises, whether the work of art is real in the transcendental sense? Without going into the controversy of whether we can logically accept the notion of such a transcendent "reality" in some realm "beyond" space and time "outside" the limits of sense-perception and rationality, we can on the basis of our preceding discussion state that if works of art do reveal a metaphysical reality

they do so only indirectly. Certainly this type of revelation is not what the artist sets out primarily to achieve. The term "reality" in connection with works of art can properly be applied only in the sense of being vividly and immediately real. They are real not inasmuch as they correspond to any observable facts in the world or to any speculative concepts of the "beyond" but to our experience of the inner meaning of life. John Hospers in his analysis of truth and reality in the arts, is close to this concept when he suggests that one of the senses of "real" specially relevant to art is the sense in which when we say of a character in a drama that it is real, we mean that it is true-to-life, or when we ascribe 'reality' to a Cezanne canvas, we mean that it is true to our experience of distance or spatial depth or form.... In this sense, to say of a work of art that it is real is to say that it reveals those "essences" which are communicable to us and verifiable in our consequent experience.[17]

The Indian conception of "reality" in the context of works of art is also used in the sense of being true to our experience of life, but this conception extends further inasmuch as it is not the experience of life in its grosser outward aspect (*sthula*) that is given, but the revelation of life on the subtler plane (*sukshma*). The experience of distance, spatial depth or form that is afforded is not the experience of the visible, tangible transitory dimensions with which we are evidently confronted but of those inner dimensions with which the inner self of the individual finds identity.[18]

The work of art by affording an intrinsic experience of life, reveals the deeper strata of life, the law and essence of

17. John Hospers, *Meaning and Truth in the Arts*, The University of North Carolina Press, Chapel Hill, 1946, p. 223.
18. "Reality, in all its manifestations, reveals itself in the emotional and imaginative background of our mind. We know it, not because we can think of it but because we directly feel it. And therefore, even if rejected by the logical mind, it is not banished from our consciousness. As an incident it may be beneficial or injurious, but as revelation its value lies in the fact that it offers us an experience through emotion or imagination; we feel ourselves in a special field of realisation...... The reality of my own self is immediate and indubitable to

(Contd.)

things. The image of the dancing *Shiva* gives us the feel of a universal rhythm and turbulence of cosmic creation and destruction. It is the presentation in visual imagery of nature's law as experienced by every man in the innermost essence of his being.

It is evident that though we have used the term "illusion" to convey the vivid and intense quality of the art object, it is not an illusion in the sense of being lesser reality than life itself, but in the sense of being greater reality, as it reveals the very life-source. The art object is an illusion inasmuch as its essential quality lies not in any aspect of its measurably physical structure but in an intangible quality which is something other than the material aspect of the work itself. What is this intangible "otherness" which constitutes so to speak the real work of art.[19] It is not an accidental and subjective phenomena which arises unbidden, due to the private state of the spectator's mind, but a phenomena planned and controlled objectively by the elements of the work itself. The degree of objectivity depends on the combination and organisation of the materials of the work. The greater the organisation of elements in a work, the greater is its integrity and independence from the spectator's reaction. No doubt, the spectator's state of mind also contributes to the sense of illusion which pervades the art object, and it is mainly due to the spectator's response that a work of art comes "to life" but this response no matter how sensitive must interact with a potentially artistic object. By potentially artistic, we mean a work that is imbibed with the artist's intuitive vision and is made up of those

(Contd.)
 me. Whatever else affects me in a like manner is real for myself, and it inevitably attracts and occupies my attention for its own sake, blends itself with my personality, making it richer and larger and causing it delight....... The consciousness of the real within me seeks for its own corroboration in the touch of the Real outside me." *Rabindranath Tagore on Art and Aesthetics,* op. cit., p. 43.

19. I have borrowed the term "otherness" from Susanne K. Langer, who uses it to convey the idea of the work of art as a dynamic image. Cf. *Feeling and Form,* Routledge and Kegan Paul Ltd. 1967, p. 45.

sensuous elements, which are *composable* according to artist-
ic principles. The point that we are trying to make is that
every work of art, apart from the aesthetic reactions it
arouses in the spectator, has an independent area of opera-
tion, limited by the specialised sense it employs. The
"aesthetic surface" of an object as pointed out by David
Prall, is something given by nature; so are the basic rules of
structure, which spring from the nature of the material, "as
the diatonic scale, for instance, stems from the partial tones
that lie in any fundamental pitch. The several arts, there-
fore, are governed by the natural departments of sense, each
giving the artist a particular order of elements out of which
he make combinations and designs to the limit of his inven-
tive powers."[20] An object according to our definition is pot-
entially artistic when it conforms to the basic rules of struc-
ture which spring from the nature of the material and
embodies the artists intuition, but has not interacted with
the spectator's mind.

The artist's conscious will and intention is the primary
and fundamental part of the art work, which in its physical
aspect is the external objectification of a fully worked out
internal process. The spectator's response brings the work
to a culmination; without the spectator's experience the
work of art remains a seed which has yet to bear fruit.

The work of art, therefore, is a composite whole. We
have seen that it does not have a definable or measurable
location, yet it has positive existence with a truth and
reality of its own. This truth and reality is one that tran-
scends the logical and physical order of things, thereby
converting an ordinary structure composed of material
elements into a dynamic work of art.

20. *ibid.*, p. 55.

The Concept of Meaning in Art

CLOSELY RELATED to the problem of truth in art is the one of meaning. We have seen the kind of truth that occurs in art is not the demonstrable and verifiable kind of truth that occurs in science and logic. Evidently, the kind of meaning that a work of art conveys is not of the conventional kind. In everyday life, in scientific and logical works we generally analyse statements and events and our reactions towards them, by saying what they "mean" to us. The question arises, can a work of art be analysed similarly? Can the meaning of a poem for instance, be given to us in the same way as the meaning of a geometrical theorem, that is, through a process of logical deduction? If this be not so, what is the sense in which we are entitled to infer meaning from works of art? In what way do such works communicate their sense to us, indeed if they do communicate at all?

Let us first see the various senses in which the term "meaning" is used. In logical and causal deductions meaning is inferred objectively from the stipulated premises as when we say, "dark clouds mean rain" or that "if ten times two is twenty, it means twenty times two is forty." In the case of emotional attitudes meaning is derived in terms of a general feeling of significance, as when we say of a town to which we are attached due to childhood memories, "this town means a lot to me". There are several such meanings of meaning. Ogden and Richards in their *Meaning of*

Meaning, list sixteen of them.[1] John Hospers gives some of
the main senses in which this term is used in his work *Mean-
ing and Truth in the Arts*.[2] But as he points out, while in
most such cases it becomes fairly clear as to what is meant
when the term "meaning" is used, confusion arises when
we try to analyse in a similar manner our responses to a
work of art and ask, "what does this piece of music mean ?",
in the same way, as we would ask "what does this mathe-
matical equation mean ?" or "what does his behaviour
mean ?" In the case of scientific statements the sense is
clearly factual and logical. What the statement means, is
inferred from the objectively presented facts either through
a process of physical verification or logical deduction. But
in the case of an artistic work, such as poetry, music or
sculpture, the meaning is not so evident, for as we have
seen it is closely connected with feeling which is
unanalysable.

John Hospers aptly questions the justification of apply-
ing the term "meaning" at all, to works of art. He poses
the problem lucidly in the following way: "It is possible to
have intense and valuable experiences in response to works
of art, without attempting to make claims for them or to
characterise the works to which they are responses. As a
rule, however, this is just what we try to do, and here end-
less confusion begins. We ask, 'What is the meaning of
this piece of music ?' without stopping to ask ourselves,
what it is that we are asking, precisely what sense of
'meaning' is being used here or what it means for a work
of art to have meaning."[3]

The problem of meaning in art (mainly poetry and
music and drama) is discussed extensively in treatises on
Indian poetics. The group of thinkers already referred to as
the *dhvani* theorists,[4] represented chiefly by Anandavardhana,

1. John Hospers, *Meaning and Truth in the Arts*, University of North
 Carolina Press, 1946, p. 74.
2. *ibid.*, p. 74.
3. *ibid.*, Introduction V.
4. We know of three important *dhvani* theorists—(1) Dhvanikara (8th
 (*Contd.*)

The Concept of Meaning in Art

CLOSELY RELATED to the problem of truth in art is the one of meaning. We have seen the kind of truth that occurs in art is not the demonstrable and verifiable kind of truth that occurs in science and logic. Evidently, the kind of meaning that a work of art conveys is not of the conventional kind. In everyday life, in scientific and logical works we generally analyse statements and events and our reactions towards them, by saying what they "mean" to us. The question arises, can a work of art be analysed similarly ? Can the meaning of a poem for instance, be given to us in the same way as the meaning of a geometrical theorem, that is, through a process of logical deduction ? If this be not so, what is the sense in which we are entitled to infer meaning from works of art ? In what way do such works communicate their sense to us, indeed if they do communicate at all ?

Let us first see the various senses in which the term "meaning" is used. In logical and causal deductions meaning is inferred objectively from the stipulated premises as when we say, "dark clouds mean rain" or that "if ten times two is twenty, it means twenty times two is forty." In the case of emotional attitudes meaning is derived in terms of a general feeling of significance, as when we say of a town to which we are attached due to childhood memories, "this town means a lot to me". There are several such meanings of meaning. Ogden and Richards in their *Meaning of*

Meaning, list sixteen of them.[1] John Hospers gives some of the main senses in which this term is used in his work *Meaning and Truth in the Arts*.[2] But as he points out, while in most such cases it becomes fairly clear as to what is meant when the term "meaning" is used, confusion arises when we try to analyse in a similar manner our responses to a work of art and ask, "what does this piece of music mean?", in the same way, as we would ask "what does this mathematical equation mean?" or "what does his behaviour mean?" In the case of scientific statements the sense is clearly factual and logical. What the statement means, is inferred from the objectively presented facts either through a process of physical verification or logical deduction. But in the case of an artistic work, such as poetry, music or sculpture, the meaning is not so evident, for as we have seen it is closely connected with feeling which is unanalysable.

John Hospers aptly questions the justification of applying the term "meaning" at all, to works of art. He poses the problem lucidly in the following way: "It is possible to have intense and valuable experiences in response to works of art, without attempting to make claims for them or to characterise the works to which they are responses. As a rule, however, this is just what we try to do, and here endless confusion begins. We ask, 'What is the meaning of this piece of music?' without stopping to ask ourselves, what it is that we are asking, precisely what sense of 'meaning' is being used here or what it means for a work of art to have meaning."[3]

The problem of meaning in art (mainly poetry and music and drama) is discussed extensively in treatises on Indian poetics. The group of thinkers already referred to as the *dhvani* theorists,[4] represented chiefly by Anandavardhana,

1. John Hospers, *Meaning and Truth in the Arts*, University of North Carolina Press, 1946, p. 74.
2. *ibid.*, p. 74.
3. *ibid.*, Introduction V.
4. We know of three important *dhvani* theorists—(1) Dhvanikara (8th
(*Contd.*)

the predecessor of Abhinavagupta, is the first to point out the inherent contradiction in the position and to state that there is no proper sense in which we can say that poetry "means" anything. At best it only suggests or evokes. To this suggestive meaning they give the ambiguous and somewhat elusive name *dhvani* which means literally the resonance or reverberation that seems to cling to a work even after the performance or recital is over. It is like an aura or powerful fragrance which pervades the atmosphere entirely with its presence.[5]

According to this theory *dhvani* or poetic meaning is characteristically different in kind from logical meaning; while poetry uses the medium of language, which is also the medium used in science, logic and daily discourse, its sense is not derived from the words in the same manner. At a definite moment poetic meaning breaks off markedly from the conventional symbolism of words and reveals a completely new sense. The distinct feature of this view is that *dhvani* does not form an extension of language in its ordinary usage, nor is it just another one of its functions, but its presentation in a unique and hitherto unperceived manner. Poetic meaning is not the meaning given by words in their logical or emotive sense, but in their conversion into

(*Contd.*)

century), his commentator, (2) Anandavardhana, and his commentator (3) Abhinavagupta. The first two are responsible for the famous *Dhvanyaloka*.

5. *Dhvani* means 'suggestive sense' or 'resonant sense', which arises from the unity of word and sense. *Dhvani* is compared by some writers to the grace and charm of a woman while the words in their literal sense, to her body (*Dhvanyalokalocana*. 1, 4-5, 1.4). We may compare with this concept A.C. Bradley's notion of poetry as a unity of sound and sense; the latter he called 'resonant meaning' as it is suggested and yet it is not anything apart from the poem itself (*Oxford Lectures on Poetry*, Macmillan, London, 1909, pp. 13-15, 26) Santayana also gives a similar idea when he talks about the fused associations which cling in the form of a suggestion to the art work (*Sense of Beauty*, Scribner Sons, New York, 1936, pp. 145-146).

Cf. *Mrichhakatika* III, 5. "To tell the truth, although the song is ended, I seem to hear it as I walk."

something new. This sense which emerges has no precise or inferrable correlation with the words of the poem.

Dhvani cannot be explained either in terms of metaphor, similie or any other figure of speech. Excellent poetry has been written without the use of a single metaphor. And equally good poetry has been written with an abundant use of it. The ornamentation of language alone does not necessarily create poetry, nor is it the outcome of style, versification or any syntactical rules. What then, is *dhvani*? The answer to this question is intimately linked with the analysis of words and their meanings. Ordinarily when we state the meaning of a word or phrase, we are stating what the word refers to, what it has by convention come to stand for. Words are conventional symbols, referring to something beyond themselves. The syntactical use of words in sentences is also a matter of convention and often meanings change with the relationship and placement of words within the sentence. According to the theory of meaning formulated by the Indian theorists words in poetry do not have this kind of relationship to their meanings, but a very special one. The theory is briefly as follows:

Poetry is the natural unity (*sahitya*)[6] of word (*sabda*) and sense (*artha*) whereby the two fulfil one another in a special relationship. This is an intimate and necessary association which signifies a kind of mutual adjustment whereby ordinary words take on an extraordinary sense.

In poetry words are employed in a manner, whereby more than their conventional meanings are revealed. The Sanskrit term *artha* refers to this comprehensive and intimate relationship which the simple terms "meaning" or "sense" cannot indicate. *Artha* implies a kind of natural and inherent relationship. It is properly speaking the inexchangeable and necessary meaning of *sabda* and not any arbitrary connection. The term *Sahitya* which came later

6. *Sahitya* is the Sanskrit word for literature, meaning union, compatibility, contact, balance, etc. The *sahitya* is of word and sense, the two are compared by Kuntaka (10th century A.D.) to two close friends, one having powers and virtues equal to the other.

to be used for literature, implies this special union between words and their sense. *Sahitya* is not only a togetherness but an inseparability as well. Consequently the term which meant originally a simple union came to signify a very special kind of relationship as can exist only in poetry. This is an organic unity; Kalidasa[7] illustrates it metaphorically by comparing poetic words to that image of Siva which is known as the *Ardhanarishvara* that is, a god who is half-male (Siva) and half-female (Parvati).[8]

Other poetic thinkers have compared this relationship to the compatible understanding that exists between two good friends (*maitri*) or to the perfect repose found by the body when in bed (*sayya*).[9] But what precisely is the inherent and natural relationship between words and meaning whereby ordinary phrases (which are the media of poetry) are converted suddenly into poetic phrases ? To pose the question in the words of the Indian theorists, what is the special quality (*visesha*) which gives to words in their conventional and literal usage an extraordinary sense, whereby they become poetic? This question demands a further analysis.

The Indian theorists recognise three logical functions of language: (1) *abidha* which through denotation gives the conventional meanings of words; (2) *tatparya*, the meaning which the word acquires within the contextual relationship of the sentence; and (3) *lakshana*[10] which is implied meaning. Often a statement if taken literally gives contradictory meanings, in which case the meaning even though it is not directly stated can be implied from the words. For instance, if we say "a house on the river Ganges" it is clearly implied that the house, is on the bank of the river and not situated on the current of water. These three functions, however, are insufficient to give poetic meaning, which depends upon another indirect function of language, namely its power to manifest a suggested sense.

7. 4th century A.D., poet and dramatist.
8. *Ardhanarishvara* is the form of Siva which is half-male and half-female.
9. Cf. note 6 above. *Sayya* means literally 'bed'.
10. K.C. Pandey, *Comparative Aesthetics*, Vol. I. The Chowkhamba Sanskrit Series, Benares, 1950, p. 225.

This point needs clarification. In scientific works and
for the purpose of everyday communication language is
used in its logical function. That is the words are employed
for the sake of the meanings they directly refer to, the
meanings they gain within the contextual relationship of
the sentence and the meaning implied thereby. Words in
any language however, are not purely symbolic, inasmuch
as the meanings which accrue to them in the course of time
are not only those which have been given to them logically,
through denotation and connotation, but also those which
have gathered around them associatively. Such words are
predominantly affective, and arouse, apart from logical
meanings, a host of emotions and imagery. Poetry uses
words predominantly in this affective way. Meanings in
poetry are not given directly, through a literal translation
of the words, but rather indirectly through their suggestive
power. The essence of poetry lies in the effect it evokes,
the imagery and feeling it gives rise to, and not in the fac-
tual accuracy of its statements.[11] In this respect it is totally
contrasted to science, wherein the function of language is
purely statement of fact.

The words in poetry actually have a double function.
As conventional symbols, they convey direct meanings. But
within the structure of the poem words also function sug-
gestively. Indirectly, they give rise to images, feelings,
affective tones, and associations. When all these are merg-
ed together, they combine to give rise to a unique kind of
meaning, which is not given by the individual words in
their normal usage. This indirect meaning is what the
Indian aestheticians call dhvani in order to distinguish it
from the ordinary and direct meaning of words.[12] Dhvani
taken as extraordinary meaning, however, does not totally
forego the symbolic use of words. The vivid imagery of
poetic language depends primarily upon a complete

11. M. Hiriyanna, Art Experience, Kavyalaya Publishers, Mysore, 1954,
 p. 6. Also cf. Dhvanyaloka 1.3-5, 11.6.
12. S.K. De, Sanskrit Poetics as a Study of Aesthetic, University of Cali-
 fornia, 1963, p. 8, 86. Also S.K. De, Sanskrit Poetics, II, p. 185.

understanding of words, first in their symbolic and then in their suggestive functions.

As John Hospers suggests, the difference between poetry and the language of science is not "that the one uses the referential function of language and the other not (or less) for both use it to the full. But the language of exact science, theoretically at least, consists of nothing but this referential or symbolic usage, while the language of poetry consists of something more. Whether a given piece of writing is poetry or prose is 'a matter of degree'; the more nearly it approaches the purely referential use of language, the more nearly it approximates the state of pure prose."[13]

A precise understanding of the symbolic meaning of words is the first essential for the understanding and appreciation of poetry. The words must be known clearly upto their finest shade of meaning and not simply grasped vaguely or obscurely. The difference between poetry and prose as already pointed out, however, lies in the fact that poetry gives rise further to a different kind of meaning. This poetic meaning emerges when the referential use of words are understood but submerged into the background. Their understanding therefore is essential but only as a prerequisite. It is when the symbolic meanings do not intrude upon the mind, but slip unobtrusively into the unconscious, that the suggestive sense is aroused. In poetry, the final effect of words is predominantly a suggestive one.

The suggestiveness however arises not because of the obscurity with which the words are endowed, but on account of the extra meaning which accrues to them when the intellectual meaning is subordinated due to other factors such as those given by sound, image, emotive and associative values. It is not the aim of the poet to make language shadowy and vague. "The referential meanings of words... constitute one factor in poetic effects; we must know them before we can appreciate them as poetry. But there are other factors as well."[14] In modern times different writers

13. Hospers op. cit., p. 126.
14. ibid., p. 127.

emphasise different effects. Richards, for instance, lays greater emphasis on emotive meaning and considers it to be the essence of poetic language.[15] The Indian aestheticians of the *alamkara* and *riti* school of thought emphasize the use of metaphor and similie in poetry which is the image-evoking power of language.

Dhvani however, is that evocation which combining all the factors presents a wholly new sense, a sense, not given by any single element, referential, emotive or imagistic, but by all of them together. This sense is unified and all pervading. It rises like an organic entity over and above the separate elements of the poem, usurping the entire field of consciousness.[16]

In reply to the question raised in the beginning of this chapter as to what is the nature of aesthetic meaning, we may now state that in poetry the meaning (if at all we use this term) lies in the suggestive power evoked by the combined effect of the words, and emerges as the result of word juxtaposition, arranged to convey direct effects through rhythm, vowel-quality etc.[17] This effect must be total and undisrupted. In science the meanings are derived by an analytical process of the literal statement of words used as symbols for meanings lying beyond them. In poetry the sense is immediately and directly presented; it appears to rise, wholly and suddenly from the words without any direct connection with the literal statements.

Another point which needs consideration is the extent to which emotive meanings contribute to the total aesthetic effect. We have seen that words in poetry are used

15. *ibid.*, p. 127.
16. "The nature of the *dhvani* is expressed by Anandavardhana in the following way (Ch. A., 14) 'In the words of the great poets a new element is to be perceived. different from any other, which transcends all the separately perceptible parts, like that which in woman is called beauty' (Gnoli, *The Aesthetic Experience*, op. cit., p. 59 note).
17. Satya Dev Chaudhary, *Essays on Indian Poetics*, Delhi, 1965, p. 21. Mammata (11-12th Century A.D.) in his *Kavya Prakash* discusses the different meanings that can accrue to a sentence. and that which makes it a poetic sentence.

predominantly for the effects they evoke rather than as simple referents. And the evocation of mood, feeling, attitude, belief, is an important if not the most important part of poetic meaning. The emotive function of language is distinguished by the fact that it has no reference to truth or falsity.[18] "Provided that the attitude or feeling is evoked the most important function of such language is fulfilled, and any symbolic function that the words may have is instrumental only and subsidiary to the emotive function."[19] Now it is true, poetry aims largely upon evoking emotional effects through the affective use of words, rather than upon giving truth or falsity, this fact however must not lead us to the conclusion that poetic language is nothing but emotive.

In the first place, it is not the function of poetry to arouse the raw emotions and personal reactions which take place in everyday life. The poetic emotion is impersonal and universalised.

This fact is fully realised by the Indian aestheticians when they define *dhvani* in terms of an objective power (*vyapara*) which appears to belong to the words of the poem itself, and not personally to the spectator.

Those modern theorists like Richards, who support the emotive theory of poetry do so on the obvious ground, that since poetry does not aim to give us logical or physical truth, its function is only to evoke emotional reaction, and to foster certain attitudes and beliefs.

The fallacy of such a position lies in inferring that because poetic meaning is not logical and symbolic, it is therefore emotive.[20] The point that seems to have been overlooked is the fact that poetic language is not that which is either symbolic or emotive, but it is a combination of both factors and their consequent subordination to the total effect. Richards makes the mistake of regarding all evocation as poetic and of identifying the emotive and the

18. C.K. Ogden and I.A. Richards, *Meaning of Meaning*, Routledge and Kegan Paul, London, 1956, p. 149.
19. *ibid.*, pp. 149-151.
20. Hospers, op. cit., p. 129.

evocative. Both his premises are wrong. Evocation as John Hospers points out is not necessarily always emotive but can be of other kinds as well, and all evocation is by no means poetic.[21] For instance, the sight of a tiger evokes terror and the memory of one's beloved evokes longing. Neither of these evocations are aesthetic and as private feelings, have no place in the work of art. Professor James stresses this point when he says: "It is misleading even in regard to intensely personal poetry to speak of poetry as using language 'emotively'. Poetry is never concerned primarily to awaken 'emotion' and 'attitude'; its concern is to convey an imaginative idea of, among other things, emotions.... This contemplative excitement is impersonal, as impersonal as that which may accompany intellectual comprehension."[22]

Hospers and James succeed admirably in isolating the issue, by emphasising its negative aspect. They indicate clearly what aesthetic meaning is not. The term *dhvani* however indicates, positively as to what aesthetic meaning *is*.

It might be added here, that the term "suggestion", which has been used to translate the term *dhvani* is not really adequate to indicate its true nature. "Suggestion" implies a measure of subjectivity and indicates a sense of obscurity, which is alien to the kind of suggestion that occurs in poetry. Here, suggestion is rather in the nature of an audio-visual effect or illusion, which is not a private phenomena, but an impersonal and objective one. It presupposes however the power of visualisation with which the spectator is endowed, and which is aroused by the stimulus provided by the external media of words.

The kind of suggestion that is meant by the term *dhvani* has some similarity to the concept of "illusion" or "semblance" with which Susanne Langer explains the nature of the total effect created by the art-work as a whole.[23]

21. *ibid.*
22. *ibid.*, p. 129.
23. Susanne Langer, *Feeling and Form*, Routledge & Kegan Paul, 1967, pp. 45-48.

Like the *dhvani* theorists, she too emphasises the marked moment wherein the work of art seems to break away from its physical surroundings and materials and begins to exist as a complete entity on its own. All the separate elements of which the work is composed, merge inexplicably into an organic whole. This conversion of the parts into a unified whole, succeeds in presenting the work in a realm of its own and imbibes it with a unique aura and fragrance. Aptly she says, the work is abstracted from its mundane surroundings. Its main quality as a work of art lies in its "otherness" from reality, which quality has been variously described as "strangeness", "semblance", "illusion", "transparency", "autonomy" or "self-sufficiency."[24] What then is created in a work of art? Susanne Langer concludes, "it is an image created for the first time out of things that are not imaginal, but quite realistic, canvas and paints or carbon or ink."[25] In the case of poetry it is out of words and phrases.

But, how can a tangible object, made out of real elements, become an image or illusory object? "It becomes an image when it presents itself purely to our vision i.e., as pure visual form instead of a locally and practically related object. If we receive it as a completely visual thing, we abstract its appearance from its material existence. What we see in this way becomes simply a thing of vision—a form, an image. It detaches itself from its actual setting and acquires a different context."[26]

Evidently, *dhvani* which according to the Indian theorists is the essence of aesthetic meaning, is such a perceptual image. Its extraordinary and unique character lies in the fact that its appearance is abstracted from its material existence, and detaching itself from its physical setting it begins to exist in a world apart.

We have said that aesthetic meaning is primarily suggestion or more precisely an evocation. This evocation is not

24. *ibid.*, p. 46.
25. *ibid.*
26. *ibid.*, p. 47.

necessarily of mood or feeling but can be of other things as well such as of images and even facts. The important point is that whatever is evoked, it is not that which forms a part of our everyday mental state, but is a state which is fundamentally unique. This does not imply that it is isolated from life but only that it is different.

The elements of everyday life are used but as materials only. The aesthetic effect is essentially other than its components. In fact, it is that which leads the mind away from its natural setting into a realm apart. The sense of this leading away is perfectly embodied in the Sanskrit term *vyanjana*, which, it is stated, alone makes *dhvani* possible.

We have said that the poetic evocation is not necessarily of feeling alone but of other things as well. In time however the *dhvani* theorists began to lay far greater emphasis on feeling than on any other aspect. Earlier we noted that the *rasa* theorists considered only eight permanent (*sthayi*) states of mind to be suitable for becoming the material of aesthetic experience. In time, the *dhvani* theorists were led to the same conclusion. For them as for the *rasa* theorists the evocation of basic mental states became the most important part of the aesthetic effect, the other factor such as the evocation of fact (*vastu)* and image (*alamkara*) receding all but completely into the background. It is not surprising therefore that in time the concept of *dhvani* gradually merged into that of *rasa* and aesthetic meaning became coeval with the aesthetic experience.

Finally we come to the question of the relationship of the work of art and the perceptual image it creates. Is there any predictable correlation between the words used in the poem and the effect that it creates? Mostly, as we have noted, the poet's concern is in the evocation of a general mood or feeling. Can this be done to any precise degree? John Hospers states:

"A skilful poet can evoke in a sensitive reader images and emotions of the greatest intensity and complexity by juxtaposing words of great evocative and associative power, and can evoke certain calculated effects more

precisely than he could ever do if he tried it by using language descriptively. The words of the poem, to use T.S. Eliot's terminology, are the *objective correlative* for the evocata; they succeed in evoking in the reader just the precise image or state of feeling that the poet intended when he employed this particular combination of words."[27]

But this kind of precision is not of the type that permits transference of the effect from one work to another in the same medium, or from one work to another in a different medium. Nor is it possible to lay down a general technique, whereby certain word combinations would always arouse specific images and feelings. For this reason poetry in one language cannot really be translated into another. Moreover, the art media as the *objective correlative* for the evocata, depends for its objectivity on the power of visualisation and perceptive ability of the spectator. It also depends upon the spectator's depth and extent of life experiences, his cultural background and understanding of the art media.

We have seen that the words in poetry do not have any conventional reference to things beyond them, their function is only to evoke certain images. The truth of these images does not lie in their correspondence to external objects but to their correspondence to the inner essence and law of things. Of this essence and law, the sensitive spectator is made aware of in the depth of his experience.

The truth of a work of art, is therefore not a truth which depends upon the demonstrability of its objective statements or upon its one-to-one correspondence to external facts, or a truth which finds its correspondence to external facts, but a truth which finds its correspondence to the experiential life of the individual, as felt in the innermost depths of his being in its permanent and lasting qualities,[28]

27. Hospers, op. cit., p. 130.
28. "Aesthetic experience presupposes a pre-constituted knowledge on the part of the spectator, of the psychic reactions etc., which are normally
(*Contd.*)

a point which will be elaborated further. Having examined the nature of communication that takes place between the artist and spectator in the absence of any "meaning" as such, we must now see whether it is possible to lay down any standards of judgement for the work of art.

(Contd.)

felt before a given situation. This knowledge is in part innate (that is, it forms an integral part of human nature) and is in part, acquired through the experience of one's own reaction and one's observation of the reaction in others" (Gnoli, op. cit·, p. 100).

SIX

The Possibility and Scope of Aesthetic Evaluation

WE HAVE discussed so far the nature of the art-work from two points of view, *one*, from that of the artist for whom it is an individual creation, an embodiment of his visualisation, something that takes shape as he expresses the inner meaning of life, its vitality and rhythm and, *two*, from the audience and spectator's point of view, for whom it is that object the perception of which affords him a singular experience of delight and fulfilment.

We have now to consider the nature of the relationship that exists between the artist and the spectator and the possibility of communication between them through the body of the art-work. The response of the spectator to the work of art is a response to an object of value; the availability of this value makes aesthetic experience worth having. It is, therefore, important that we try to discover how this value is assigned and where it is said to reside and what validity it may claim. Is the focus or seat of this value in the mind of the observer, or, is it in the object, or, is it in a relation between the two? Does the observer create the value himself or does he merely discover it in the object? What part does the creator play in contributing towards this value? These are some of the more important questions that will arise in the course of our discussion.

In Indian thought the function and possibility of aesthetic evaluation is summed up briefly by Bharata in a well-known aphorism.

"Born in the heart of the poet, it (aesthetic experience)
flowers as it were in the actor (in drama) and bears fruit
in the spectator. All three in the serene contemplation
of the work, form in reality a single knowing subject
fused together."[1]

The general conception of art-evaluation enunciated
here, conceives its major business as an imaginative recrea-
tion rather than art assessment or appraisal. It pre-sup-
poses that the spectator and artist during the aesthetic
moment share a single experience. Even as the seed that
is sown, the tree that it grows into and the fruit that it
eventually bears, are different aspects of a unified process,
which means that all three stages of the creative activity are
in reality one. The whole process which starts from the
intuitive moment in the mind of the creator finds its ex-
pression in the body of the object and fulfilment in the
appreciation of the observer. In the absence of any one
stage the entire creative process is incomplete.

Does this commit us to the view that the artist always
creates for an audience? In a way, yes. The artist does
always create for another, even though the spectator may
be sometimes none other than himself. Every artist com-
bines in himself the qualities of the creator and the specta-
tor, of the artist and the critic. For the traditional Indian
artist, the articulation is indeed an act of externalisation.
This point will presently be dealt with more fully. Here
we only wish to emphasise the often overlooked fact, evi-
dently due to the great influence of Benedetto Croce's theory
of art as intuition,[2] that art is essentially a making which
involves a maker, an actual process of making, and the
made object.

The entire qualification for and imaginative recreation
on the part of the spectator is artistic sensibility of the
same kind as the artist possesses. Such an ideal spectator

1. *Natyashastra*, VI, V. 42; Abhinavagupta's *Abhinavabharati*, p. 295;
 Gnoli, *The Aesthetic Experience* p. XXVIII.
2. Cf. Benedetto Croce, *Aesthetic* tr: Ainslee, Macmillan, London, 1922,
 pp. 1-12.

is known in Sanskrit as the *sahridaya* which means literally one possessing a heart similar to that of the creator, that is, a "poetic heart."[3] This identity of attitude and feeling is a primary assumption made by the Indian aestheticians who look upon the process of appreciation to be qualitatively no different from the process of creation, the difference being only one of degree. This non-difference is clearly brought out by the use of the same set of terms to signify the artist's talent as well as the observer's experience; for instance, the term *pratibha*, meaning literally 'creative energy' is also used to signify the aesthetic response, even as the all comprehensive term *rasa* is used to denote both the experience and the art quality. It is the *rasika* alone who is capable of tasting *rasa* as the artist alone is capable of producing it. Visvanatha says that the only proof of the existence of *rasa* is its relish by the *sahridaya*[4] The response of the spectator is referred to as *ubodhana* which is an active mental revival or reproduction and not a passive appreciation or critical appraisal.

If this position is accepted then it follows that evaluation in art is primarily a matter of sharing and reviewing an experience. It is not a matter of making value judgements by deductive and inductive inference; nor is there any sense in analysing the means by which communication is effected between the artist and the spectator, for the work of art is something other than a mere physical object. All that the artist does is to assemble and present his materials, what Bharata called the Determinants (*vibhava*), Consequents (*anubhava*) and Concomitant Effects (*vyabhicaribhava*), in such a manner that together they provoke in the spectator a feeling similar to what he is experiencing.

The evocation of a mood in the spectator identical to the artist's is possible due to the prevalence of two sets of

3. *Sahridaya* means literally 'of similar heart' that is, one who through cultivated sensibility is able to identify his mood with that of the artist. The term also means the 'enlightened' or 'cultured' *(vidagdha)* critic. *Abhinavagupta on Natyashastra* p. 281/12, p. 287/7·

4. Visvanatha, *Sahitya Darpana*, III, 26.

conditions. First, the possession by all human beings of certain common traits, tendencies and emotions (*bhava*) some of which may not be evident but nevertheless are latently present in the sub-conscious. These are known in Indian speculative thought as *samskara*;[5] some of these can even be so deep-rooted as to go back to a previous life-time; these are called *vasanas*[6]. These influences form a part of man's racial consciousness and belong elementally to each one of us. A successful work of art aims at evoking these latent tendencies in every member of the audience. It thereby makes the experience communicable, between the artist and the spectator, and between the members of the audience themselves.

Since the artist possesses a nature qualitatively similar to the spectator's, he is able, through the presentation of generalised moods, to elicit from him feelings similar to his own. Aesthetic experience is possible due to the existence of preconstituted knowledge and feeling on the part of the spectator, this experience being in part innate and in part acquired through the experience of our own reactions and our observation of reactions in others.[7] Abhinavagupta says that poetic sensibility is the faculty of entering into identity with the heart of the poet. Of course people whose nature is gentle (*sukumara*) will have a greater feeling for erotic poetry; people of bolder nature will have for heroic poetry etc.[8]

The second set of conditions which allows the identification of the artist and spectator to take place is the fact

5. The word *samskara* refers to the impressions which exist subconsciously in the mind, of the objects experienced and which can be revived through key experiences and words.

6. *Vasana* comes from the root *Vas*, to stay. It is often loosely used in the sense of *samskara*. But *vasana* generally refers to the tendencies of past lives which lie dormant. *Vasanas* are innate *samskaras* not acquired in this life, whereas *samskaras* are subconscious tendencies which are revived through appropriate stimuli. Surendranath Dasgupta, *A History of Indian Philosophy* 5 Vols., Cambridge 1932-1955, Vol. I, p. 263.

7. Gnoli, op. cit., p. 100, note 4.

8. *Abhinavabharati*, II, p. 339.

that we can remove successfully those mental obstacles (*vighna*) which inhibit our responsiveness and stand in the way of a free exercise of artistic intuition. As mentioned earlier, the primary qualification for the creation of art as for its appreciation is artistic sensitivity, which talent though innate and universal, generally tends to get clouded over because of the intrusion of practical interests, intellectual or even social, moral and religious prejudices, doubts, false conceptions, egocentric tendencies and other inhibitions. For instance, if a spectator at a dramatic performance, doubts the authenticity of the characters portrayed and feels the whole thing to be anti-realistic, he will be seeing the show as a portrayal of real life and his perception of dramatic form and poetic feeling as conscious illusion, is likely to be frustrated. He may be naturally quite sensitive and responsive to other art forms like music and painting, but anything he identifies as 'drama' will be beyond his appreciation. This intellectual prejudice engendered by a theoretical conviction (that drama must necessarily portray life as it is) stands in the way of his responsiveness. Countless more examples can be given from the arts to show how such preconceptions and fixations, individual to every one, do not permit a universal aesthetic response.

Another type of prejudice which commonly occurs is the result of laying too much emphasis on categorisation and classification in the arts. This tendency is due mainly to the formal type of instruction which is imparted in the arts. It causes us to think of art forms not as individual creations but primarily as examples of schools, periods, styles or the classes that Croce decries. This kind of thinking stands in the way of a free uninhibited response. Instead of responding directly and spontaneously to the work itself, we think about it as a type, proceed to gather all the available data regarding its method and style of production and thereby succeed only in making an intellectual judgement and not an aesthetic response.

The exhilaration of a direct experience, of actual sharing and participating, comes readily when the mind is cleared of all prejudices and preoccupations. Abhinavagupta and

his school of thought lay the greatest emphasis on this
mind-clearing discipline, considering it to be the primary
requisite for proper art appreciation. They list seven major
obstacles, which generally stand in the way of a pure ex-
perience, or in the current language of Edward Bullough,[9]
which prevent us from maintaining an adequate psychical
distance from the work, whereby we loose the full enjoy-
ment of it. These are:[10] 1. "Unbecomingness (*ayogyata*) of
perception, called lack of versimilitude". This means simply,
that when the artist presents fantastic or unrealistic themes,
the spectator finds them difficult to accept and he assumes
a sceptical attitude. This kind of attitude is not conducive to
the aesthetic experience. Therefore the artist employs certain
devices in order to make the themes artistically acceptable.
One such device, for instance, is to introduce famous or
legendary personalities around whom the fantastic themes
can revolve with credibility, or he tries to create a kind of
total atmosphere wherein even the fantastic appears to be
credulous. In such circumstances the spectator willingly
suspends disbelief and permits his scepticism to be over-
come. 2. "Immersion in temporal or spatial determina-
tions which are exclusively one's own or exclusively those
of another." This obstacle is primarily due to the specta-
tor's peculiar mental make up, whereby he finds it difficult
to transcend his private sensations and reacts to the art
work as he does to things in ordinary life. This fault is the
result of an excessive 'underdistancing'. It is best represented
by the type of reaction made by the simpleton who, witness-
ing a drama for the first time, tries to intervene on behalf
of the hapless heroine who he thinks is suffering in actua-
lity. Bharata's well-known injunctions concerning the
enactment of certain ritual preliminaries like benediction,
dance, etc., before the commencement of the performance is
designed to draw the mind of the spectator away from too
great a pre-occupation in his own affairs. In this way, the

9. Edward Bullough, "Psychical Distance as a factor in Art and an
 Aesthetic Principle" in *British Journal of Psychology*, 1912, V, pp. 84-
 98.
10. Gnoli, *The Aesthetic Experience*, op. cit., pp. 48-98.

dramatist subtly leads the mind of the spectator away from practical concerns and prepares him for an aesthetic experience. 3. "The fact of being at the mercy of sensations of pleasure etc., which inhere solely in ones own person." This is quite similar to the above referred to obstacle and arises mainly due to the spectator being unable to detach himself from common pleasure, and from a submission to passion. It can be overcome by the employment of certain technical devices on the part of the artist who tries to present his material in such a manner that the mind of the spectator is drawn away from his personal affairs. Formal music and dance, according to these aestheticians usually help to bring about a state of aesthetic receptivity in most people more easily than poetry and drama alone can do, hence these should be introduced along with the play whenever necessary.

4. "Defective state (*vaikalya*) of the means of perception," is a physical handicap which naturally affects the quality of the perception. 5. "Lack of evidence (*asphutatva*)." The normal spectator requires a complete audio-visual impact in order to respond aesthetically. The art-work must make an actual presentation, concretely embodying all elements it wishes to present in order to draw out an immediate reaction. Unlike science and other academic subjects (*shastra*) the essence of art does not lie in what is inferred and not directly perceived, but in what is actually 'shown'. That which is not given cannot be inferred and is considered to be a lack of evidence. Bharata and other Indian aestheticians list a number of kinds of representation and styles which help the artist to project his intuition and create a better impact. Needless to say a sensitive spectator will not need all the techniques of presentation, but will be able to discern the artistic quality without its full and actual presentation. For instance, the reading of drama or poetry alone without its acting or recitation is sufficient for such a man to derive from it complete aesthetic pleasure.[11] 6. "Lack of pre-eminence (*apradhanata*)." This obstacle to aesthetic

11. *ibid.*, p. 84.

experience embodies a great psychological insight. It is based on the principle that the supreme human motive is pleasure, not pleasure taken in the hedonistic sense, but a non-sensuous, undisrupted delight. *Rasa* itself is predominantly this delight which when prolonged and intensified is akin to beatitude. Beatitude is the plenum of consciousness, the full enlightened awareness of "I" when the mind rests finally on this subjective essence; complete within itself it finds a perfect joy. This concept is explained in the *Vyasabhasya* (2, 4)[12] by the example of a man who is hungry and whose mind cannot find the joy of fulfilment due to being obsessed by a want which can be satisfied only by something external to himself. The aesthetic delight arises, according to the Saiva philosophers, when the subject finds a pre-eminent state of mind within which it can absorb itself, undisrupted by any need beyond itself or other than itself. The nine *rasas* given by Bharata and accepted in full by those who followed him, are those states of mind which are based on relatively permanent conditions, and thus are able to enlist wholly the subject's consciousness. Any art work, based on an ordinary fleeting emotion (*bhava*) cannot enlist the undivided attention of the spectator for long, who due to the many distractions, desires and needs that arise, cannot experience supreme beatitude. These needs etc., are the obstacles to be removed from the experience of a pure delight.[13] 7. "The fact of allowing admission

12. *ibid.*, p. 88.
13. Bharata analysed human emotions into eight principal ones and thirty-three subordinate ones. Poetry, music or drama which is essentially the evocation of a mood, must contain one dominant principal emotion, with the others supporting it. Two or more moods, he argued, break up the unity of the composition, and a piece based on a subordinate emotion fails to sustain the undivided attention of the spectator. The principal human emotions (*sthayibhava*) are the following: love, laughter, sorrow, anger, heroism, fear disgust and astonishment. The principal subordinate emotions are the following: discouragement, weakness, apprehension, weariness, contentment, stupor, joy, depression, cruelty, anxiety, fright, envy, indignation, arrogance, recollection, death, intoxication, dreaming, sleeping,

<div align="right">(<i>Contd.</i>)</div>

to doubts." This last obstacle arises when the spectator tries to generalise conclusions in art drawn from particular instances. We have seen there is no logical connection between the elements presented in an art-object and the experience they evoke. The experience is evoked, not because the spectator makes a quick inference, such as "tears mean sorrow, laughter means joy", but because the spectator can find within himself emotions and feelings similar to those presented in the work of art and is able to respond readily to them. The materials of art simply arouse the emotions already present in us; they act merely as stimuli, Aesthetic experience is possible because the human mind bears the latent traces of all its experiences and these come to the fore during the aesthetic moment, thereby enlisting the individual in an active participation. The aesthetic response lasts as long as there is an actual participation. *Rasa* is not the object of cognition nor the cause of it; it is not that which is realised in feeling but the feeling itself; not that which we taste, but the tasting itself. Anything not directly tasted, experienced, felt or shared gives rise to doubt and presents itself as an obstacle. The artist's purpose is to eliminate these doubts by presenting his work in a manner which permits the spectator to immerse himself, so to speak in his own consciousness. "Aesthetic enjoyment consists in the tasting of ones own consciousness; this tasting is endowed with extreme pleasantness (beauty) which it contains from a contact with the various latent traces of pleasure, pain, etc. It differs both from ordinary perception which is full of obstacles (pragmatic requirements etc.) and

(*Contd.*)

 awakening, shame, mental aberration, distraction, assurance, indo-
 lence, agitation, deliberation, dissimulation, sickness, insanity, despair,
 impatience, and inconstancy. These fleeting states of mind should be
 used by a clever dramatist to support the main emotional theme; they
 contribute when used correctly, towards bringing out an aesthetic
 emotion, but if made into the main theme, the drama (poetry, music)
 fails to sustain long drawn-out attention, and thus never leads to the
 state of undivided joy (cf. Gnoli, *The Aesthetic Experience*) op. cit.
 pp. 29-30.

from the perception of *yogins*, which is not free from harshness on account of the lack of any tasting of external objects."[14]

The mental disciplines described above, it must be pointed out, are only the necessary pre-conditions of the aesthetic response and not characteristics of the response itself. They succeed in disengaging the mind from its immediate environment, a disengagement which is essential for the free activity of the mind, but the attitude engendered by this detached withdrawal is not by itself aesthetic. These conditions, by the removal of all personal factors which are likely to influence the making of an objective judgement, prepare the ground so to speak, for a universal consent. This is the negative side of the aesthetic response; its positive side is characterised not by a passive withdrawal but by an active participation and identification.

The objectivity of aesthetic valuation, depends undoubtedly on the quality of the spectator's understanding even as Kant observed in the *Critique of Judgement*, the beauty of nature is its conformity to our understanding and conformity is something originally imposed in it by our intuition.[15] But that wholly individual warm, intimate aspect of the response which makes it truly aesthetic, requires qualities other than those of understanding alone.

From this account a number of implications follow. *First*, that the aesthetic response, subjective as it is, does involve a degree of objectivity, thereby endorsing the judgement made thereupon with a measure of authority. Objectivity, however, that accrues to these judgements is derived not from any criteria—qualities present within the art-object but from the nature of the mental and emotional equipment with which the spectator is provided. Behind the individual evaluation of a particular work no general theory is involved, which can guide critics to formulate hypothesis about a standard which all artists ought to

14. *Abhinavabharati*, I, p. 291, translation by Gnoli.
15. Immanuel Kant, *Critique of Judgement*, Tr. James Meredith, Clarendon Press, Oxford, 1911, p. 34, Introduction VIII.

achieve and by which their works may be judged. We know that when such standards are sought to be stipulated as is done in every age, by the setting up of the various canons, schools, period, styles and standards, they possess only a limited value and are frequently transcended by original artists. The law of the artist is a law from within.

The *second* implication that follows concerns the nature and possibility of the aesthetic valuation. Clearly the aesthetic judgement which forms the basis of all our evaluation and criticism, is of a different order from (a) the response itself, and from (b) logical, scientific and moral judgements. Inasmuch as the aesthetic judgement concerns the estimating of the value of a work of art in relation to other works of art and to other human values, it exercises the cognitive faculties of man and as such is distinct from the level of art intuition. Judgement is a necessary and closely allied phase to that of imaginative recreation and appreciation, but it is nonetheless distinct. In order to realise the exact nature of the distinction let us first understand the function of critical activity as against the contemplative spirit of the aesthetic response. Practical judgement and criticism which involves the appraisal of particular works involves a number of aspects. Greene aptly points out that "A work of art is a unique whole, a self-contained artistic 'organism' with a 'life' and reality of its own. But it is also an historical phenomenon, the product of a specific school, period and culture, and an exemplification of stylistic characteristics which it shares with other works by the same artist and of the same school, period and culture. *Finally*, works of art vary in artistic excellence, truth, and significance; every work of art possesses its own degree of perfection and its own measure of truth or falsity, triviality or greatness."[16] In order to achieve a re-creation of the work in his own mind, the spectator is expected initially to understand the artist's "language". This implies knowledge of the technical "knowhow" of a particular art

16. Theodore Meyer Greene, *The Arts and the Art of Criticism*, Princeton University Press, Princeton 1940, pp. 369-373.

form and familiarity with the generic style of the work and
its historical and cultural setting. It is when the task of
re-creation is over that the mind naturally seeks to estimate
the value of the work. According to Greene these three
aspects, namely, the historical, re-creative and judicial, are
complementary approaches to the work of art, and for a
valid criticism all three must be present together. No doubt
he is right in emphasising the value of historical orientation
and judicial appraisal for assisting and conditioning the
task of re-creative apprehension, but it must be emphasised
that these aspects can only complement, before and after,
the supreme moment of the aesthetic response and not form
an integral part of it.

 Criticism strictly belongs to the first and final aspect
alone of the appreciative process, that is, to the stage of
historical reconstruction and judicial appraisal. At these
levels it performs the important function of contributing to
our understanding of the art-work, the background in which
it was constructed, the medium, technique and methods
employed. It helps us to understand the artist's language
and idiom. But unless the critic transcends this level and
keeps clear of the intrusion of judicial appraisal and of all
the influences, intellectual, academic, historical etc., and
otherwise, he can never achieve the degree of sensitivity,
detachment and artistic responsiveness, which is necessary
for a perfect re-creation, and consequently objective judge-
ment. A man can never achieve the status of an ideal
beholder, the *sahridaya* unless he goes, so to speak, beyond
"criticism". At this level he is more than a mere "critic" be-
ing akin to the artist in his contemplative attitude, which re-
quires the greatest activity and is not a passive state of mind.
Within the supreme moment of the aesthetic response when
the spectator and artist are one in spirit, all critical dis-
course is subordinated. This does not imply that it does
not exist, nor that it is not necessary but that its function is
relatively limited.

 Even as the artist needs technical devices and the skill
to employ them, in order to express his intuition, the spec-
tator needs to be completely aware of the artist's medium

and method in order to perceive and fully appreciate his intention. Criticism may accompany the aesthetic response but is not a part of it. Artistic sensitivity alone can reveal what is and what is not "a work of art" and no critical verdict upon it can alter the nature of the agreement.

Criticism does not belong to the response itself, but accompanies it so closely that it appears to be a part of it. Its significance however lies not in any influence it exerts on the nature of the response evoked in the spectator but in the fact that it reinforces intellectually a decision at which he has already arrived at through intuition.

Clearly then art evaluation and criticism are processes distinct from art intuition, and the genuine connoiseur (*sahridaya*) is a different person possessing different qualities from the "critic". It is of course possible that both the qualities of critic and *sahridaya* are combined, and indeed this is often the case, but the one quality does not presuppose the other. There are countless "critics" who pass only intellectual judgements on art-works bringing to the notice of the audience remote points concerning the artist's biography, authenticity and method of work. At best they perform the task of identifying the style, period and school to which the work may belong, whether it is purely formal, or purely descriptive or mixed with foreign elements, and so on. Such men may never have had an undiluted experience and consequently their evaluation of the work's artistic worth will be distorted. On the other hand, there are countless sensitive connoiseurs, who without any familiarity of the cultural mileau in which the artist has lived and created, can identify themselves with the work completely.

While the art-object is primarily a product of its age and time and these factors are of major importance in establishing the necessary involvement between spectator and audience, they can be overcome by the man who possesses a "poetic heart" and the artistic worth of the work can be appreciated despite the barrier of "psychical over-distancing" they normally create.

Distinct as the aesthetic judgement is from the intuitive

moment, it is nonetheless an essential aspect of the creative
process and, as we have seen, is so closely allied to the art
intuition as to be almost indistinguishable from it. Indeed,
it derives its validity and authority from the absolute cer-
tainty of the intuitive moment and as such invests aesthetic
judgement, even as Kant realised, with a subjective univer-
sality. Clearly, a judgement which derives its validity from
the personal qualities of the judge and not from those
which present themselves in the case, is a judgement of
quite a different order from logical, scientific and practical
judgements which are based on the facts of the case.

Without going into a detailed discussion of what is
judgement and the various kinds of judgements that are
possible, one might say broadly that to judge some-
thing implies the use of a definite procedure and not the
arrival at a decision on the basis of personal inclination.
Neither are judgements simple descriptions of physical or
physiological fact. The procedure of arriving at a decision
from given facts need not necessarily be the logical one of
relating evidence to conclusion as in deductive and inductive
inference. When works of art are evaluated in respect of
other works and terms such as "good" and "better" con-
ferred on them, the valuation is not made on the
basis of any criteria-qualities given in the work from
which the conclusion is drawn. Neither is the evaluation
based on a simple feeling of the assessor. It is derived from
the intuitive certainty through which the sensitive spectator
has passed, and which has enabled him to reconstruct as
objectively as possible the work as it was created by the
artist. The function of the true critic, therefore, must be
not to discover but to re-create. Criticism and appraisal
too, should be more like creation than like demonstration
and proof. To judge an art-work, is not to assess it on its
merits or demerits but to pass an unconditional verdict with
which others may or may not agree, but for which there is
no "proof" but only "agreement." There is no logical
justification for approving an art-work, as there is no sense
in which we can justify our affections and antipathies. For
a work either appeals or it does not, and no "reasons" can

possibly make us enjoy what we have rejected on the basis of experience. This does not imply that no definite procedure has been followed and hence the judgement is an arbitrary one, but that it is of quite a different order from the objective method of logical judgement.

Does it then follow that there can be no education in art; is it that the one who is not fortunate enough to possess the primary qualification for appreciation is not capable of developing a taste for it ? Also, that if a work has no appeal in the first instance, there is no future possibility of liking it ? No doubt the capacity for intuitive visualisation is innate and as such cannot be learnt, but there are some methods whereby the capacity may be enhanced. It is the artist's business to present his work in as objectively pleasing a manner as possible, so as to attract the spectator in the first instance, and involve him personally in the contemplation of the work as well to bring about in him, through the application of appropriate psychological and technical devices, the required detachment. This two-fold task requires the greatest skill and imaginative ability; it is such a subtle interplay of forces that the slightest imbalance on one or the other side can destroy completely what might otherwise have been a work of art.

While no formal instruction can teach a spectator how to "involve" and "distance" himself simultaneously, a skilful artist can and does present his work in a manner as to "show" the spectator what he wants. The point we are trying to emphasise is, that instruction can take place in the arts, by exposing people frequently to art and thereby permitting them to develop from within and through experience their intuitive and imaginative faculties. This development is not an unconscious or passive process, but a highly stimulating and fully conscious activity. Taste in people is developed not by understanding principles of beauty but by experiencing them and absorbing them within oneself.

The critic likewise must not attempt to formally teach people the principles of art in order to develop in them a taste for it, but to bring to their notice the truly artistic

moments and their end-products which might otherwise
escape attention. By high-lighting and repeating such per-
formances and by eliminating all that is in bad taste and
unworthy, the critic can perform the very important task of
educating people in the arts. He must show them how to
respond aesthetically and not explain to them when and
why they should respond.

The task of criticism, therefore, we suggest, is not to
give general criteria as "reasons" but to "convey" the art-
istic qualities as artists do by creating them. It is in the
use of an indefinite set of devices for "showing" and not
"explaining" the merits of art, that true criticism lies.

It is significant that the traditional Indian aestheticians
never bore the burden of critics as we do in modern times.
For them, as we have mentioned, criticism was not a neces-
sary or separate function but a subordinate part of the
entire creative process. Every artist, they maintained, is
himself a creator and a spectator, an artist and a critic,
even as is the *sahridaya* who is essentially one in spirit with
him. Consequently, the services of an outsider like the
critics of today, were never really required, art being, as
they fully realised, wholly a matter of personal and direct
experience.

In most cases, it was left to the efforts of the individual
himself to develop his own sensibilities. This could be done
through the arduous practice (*abhyasa*) of prescribed personal
disciplines such as those which enhance concentration, help
detachment and permit identification. In most cases, these
practices were similar to the first stages of *yoga*; indeed, the
artist in fact, and even the skilful craftsman were given a
status similar to that of the *yogi*. "I learned concentration
from the maker of arrows", said Shankaracharya, in deep
humility of spirit.

Finally, it remains to be asked whether our account of
the nature of aesthetic value commits us wholly to a posi-
tion of complete subjectivity whereby beauty is resolved
into a type of emotional effect consisting in the feelings
which certain persons of taste entertain in regard to a work
of art, or to a position of relative subjectivity whereby

beauty refers to a relation subsisting between the artist's mind, the spectator's mind and the art-object in question ? And if this be so, is it implied that beauty as an objective value, self-sufficient and independent of any other factors in the universe, does not exist?

In the theories of art that obtain today, protagonists do tend to commit themselves to one or the other viewpoint. The extreme subjectivist position is chiefly represented by Tolstoy in *What is Art* ? wherein he identifies art with the communication of emotion,[17] and the extreme objectivist point, by Joad,[18] wherein the objectivity of beauty as a general concept is sought to be established. Others take positions half-way along the line, accepting with modifications one or the other view, but which on analysis reduce themselves to the basic standpoint of complete subjectivity which Tolstoy embraces or total objectivity which Joad advocates.

The view of the traditional Indian aestheticians does not commit itself to either of the above positions. To try to assign it to one or the other camp, or to a position half-way in between, is to misrepresent its essential nature. In Indian idealist thought the subjective and objective are not polar principles, but in their essence one. The two, the objective and subjective, the cosmic and the psychical principles are looked upon as identical. The inmost individual being is recognised to be the inmost being of universal nature and all her phenomena.[19] Beauty has therefore both an objective and subjective value, it being an all pervasive, all inclusive quality belonging equally to the object which contains it and to the subject who perceives it.

17. Leo Tolstoy, *What is Art*, Oxford, 1924, p. 173. "To evoke in oneself a feeling one has experienced and, having evoked it in oneself, then by means of movements, lines, colours, sounds or forms expressed in words so as to transmit that feeling that others experience the same feeling—this is the activity of arts."

18. C.E.M. Joad, *Matter, Life and Value*, Oxford University Press, London, 1929, pp. 253-283.

19. S. Radhakrishnan, *Indian Philosophy*, I, pp. 168-69. Allen & Unwin, London, 1958.

It does not lie in the communication of emotion alone, nor is it a property of the object existing independently of a perceiving mind; it is rather that value which is discovered when we go beyond individual feeling and perception and directly experience the essence of the object. The perception of beauty is not the perception of an object as something different from the subject but its experience as something none other than the subject. From this point of view the controversy of whether aesthetic value is a subjective principle measured in terms of individual feelings, or an objective property of things is irrelevant. From one aspect it is completely objective, for the quality of beauty is not affected by the varying judgements pronounced upon it in different generations, or by different people in the same generation. A man of good taste will invariably discern value in whatever form it may appear and public approval or disapproval will not affect his judgement. And a man of good taste, we define, not as one who is impulsive and whimsical but as a person who consistently passes judgements on the aesthetic value of works of art which are reasonably near the truth, or nearer the truth than most. It follows from this, that it may not always be possible to decide with certainty who is a person of good taste and who is not. This decision can only be borne out by experience. The point however is, that good taste is not a private judgement; as we have already pointed out certain mental attitudes are necessary to acquire prior to the passing of accurate judgements. These mental attitudes include the acquisition of a certain frame of mind which must be free from all turmoil. The achievement of such a state of mind, known traditionally as *sattvik* and which means literally, one of purity, is insisted upon by the Indian thinkers, in order to ensure the objectivity of the response. While the water is troubled it cannot reflect, but that does not prevent the sky from being there.

Aesthetic value has an objective quality inasmuch as the spectator's reaction does not alter the fact of its subsistence, but only reveals it. The nature of this objectivity, however, is not of the type prevailing in science and logic,

for its discovery depends not on objective methods, which can, through a knowledge of their application, be employed by anyone. It depends rather on the possession of a clear, lucid state of mind which can be acquired only by great personal effort. It is in the total awareness within oneself of the objective value without, that beauty has its proper locus. Like the values of truth and goodness, beauty for the Indian thinkers exists, not as an abstract principle or general concept, but as a living experience. From this we can conclude that while beauty as an objective principle may have potential subsistence as a fact of the phenomenal world, it exists actually in its realisation by a subject, and it is here that its proper value, whereby it becomes truly aesthetic, belongs. Aesthetic value lies in the state of identity achieved by the subject in its full awareness of the object, whereby the subjective and objective as contradictory principles are sublimated and transcended. Therefore, beauty is as completely subjective as it is objective and the attempt to pinpoint it on one or the other side is a misguided attempt which gives rise to many questions which cannot be directly answered. Such questions, for instance, as to how we can perceive and understand artistic value correctly, how we can rate a work of art among others, and judge its value properly, whether beauty is a property of things, independent of a perceiving mind, etc., really have no answers as they are based on fundamental misconceptions which are expressed in the terms that are employed. We have seen that beauty cannot be properly an objective property of things and hence a work of art cannot be said to effect a *communication* at all but a communion wherein all those who belong to an identical state of consciousness, participate. The problem of aesthetic valuation sorts itself out when it is kept clear of such intellectual discussions which can be at best relative and empirical, and becomes a living experience. As such art assumes a significant function in the life and development of the individual and of the society which is constituted of such individuals.

We shall now proceed to discuss the function of art and its value for human living.

The Function of Art

ACCORDING TO a well-known Indian concept, human action is four-fold as it subserves the four main ends (*purushartha*) of life, namely, right action (*dharma*), satisfaction of desire (*kama*), acquisition of wealth (*artha*) and achievement of spiritual freedom (*moksha*).[1] Of these the first three represent the proximate goals of living and the last the ultimate end. Art as a necessary human activity and process which takes place within a social context, finds its justification in subserving these ends; at a lower level it subserves the first three worldly aims, and at its highest, the goal of spiritual freedom (*moksha*).

The rationale of this four-fold categorisation lies in its intention to use art through the separate phases of life, for the attainment of the final end. If looked at from the modern psychological point of view, not as separate intentions of life but as two pairs of interacting necessities inherent in the nature of things, the classification shows admirably the intimate relationship in an art-work of the sensuous,

1. A.K. Coomaraswamy, *Transformation of Nature in Art*, Dover Publications, New York, 1956, p. 46.

 In his *Natyashastra*, Bharata claims that drama is an instrument for achieving virtue, fame, long life, and benefaction. It also enriches the mind and imparts instruction (I. 115). For Bhamaha and those who followed him, like Rudrata, Kuntaka, Visvanatha and Mammata, the purpose of drama and poetry was essentially for the attainment of the four-fold aim of life called *caturvarga*. Some of them also add the aims of pleasure, fame, instruction, etc.

mental and spiritual elements. It provides a basis for the
artist to liberate himself, from the gross pleasures of life,
pursued blindly, and to attain the crystal clarity of intuitive
thought. *Moksha* alone as the final end of all artistic acti-
vity justifies the artist's immediate goals.[2]

The main body of Indian aesthetics incorporates this
view as presented originally by the *alamkara* theorists.[3] It is
unequivocally functional in its approach, the idea being
summed up in the *Sahitya Darpana*; "All expressions (*vakya*),
human or revealed, are directed to an end beyond them-
selves (*karyaparam*) or, if not so determined, are thereby
comparable only to the utterances of a mad man."[4] The
theory is functional as it implies that art is not an end in it-
self but a means for the securing of certain other ends. It
asks of art a service to life beyond that of pleasure, as dis-
tinct from the commonplace pleasures derived from com-
mon place objects of pleasure.

The demand that a work of art must do something apart
from simply being a source of pleasure, emerges from the
notion fundamental to Indian thought that there is an inti-
mate and immediate connection between man and the uni-
verse, that connection being of the nature of a participation
in the one unified essence of being.[5] It is this essential identity
which makes it possible for man to direct his thought and
creative expression to an end beyond himself. For accord-
ing to the Upanishadic formula "That thou art" (*Tat tvam*

2. James Cousins, *The Faith of the Artist*, Adyar, 1941, p. 50.
3. A.K. Coomaraswamy, op. cit. "Meaning or Utility is the indispensable
 motive of all art, but from the Indian point of view that is not art
 which does not also subserve the ultimate end of aesthetic experience",
 p. 195.
4. *ibid.*, p. 47, *Sahitya-Darpana* V.I.
5. S. Radhakrishnan, *Indian Philosophy Vol. I*, Allen & Unwin Ltd.
 "The two, the objective and the subjective, the *Brahman* and the
 Atman, the cosmic and the psychical principles, are looked upon as
 identical. Brahman is Atman", p. 169. "From the beginning of
 reflection this oneness of subject and object, the existence of one
 central reality, pervading and embracing all has been the doctrine of
 the devout", p. 170. Cf. *Taittiriya Upanishad*, 1.5 *Chhandogya Up.*, iii.
 13.7 *Brihadaranyaka Up*, V. 5.2.

asi),[6] the causes lying deep within nature are simultaneously those which belong to the innermost being of man.[7] Applying another Upanishadic statement[8] we might perhaps say in the context of art "Not for the sake of art is art dear but for the sake of the self art is dear." That is, for the sake of something in the depths of our nature, something which is akin to the creative spirit of the universe and gives art the touch of religion.

The function of art is consequently to serve the very highest end, for art in a unique manner makes us aware that in our composite nature there is a capacity to feel total happiness and experience complete fulfilment. Art is functional not in the sense of simple usefulness to daily ends as the utilitarian philosophers have held, but in the seeking of a higher value to life. It is not limited to the deliberate portrayal of themes calculated to elevate the artist or the spectator. There is no relationship between art and dogmatism or art and zealotry, nor is it the business of art to propagate institutionalised ideas, or convey moral messages pertaining to social or individual duty. This does not mean that the practical ends are not satisfied nor that these ends are not important; it only implies that art does not fulfil its proper function if it does not lead the artist gradually away from these relatively grosser objectives, to the final goal of human liberation.

6. *Chhandogya Upanishad*, vi. 10 ff.

7. S. Radhakrishnan, op. cit., "Religious mysticism and deep piety witness to the truth of the great saying "That thou art" *Tattvamasi*. We may not understand it, but that does not give us a sufficient right to deny it". Also cf. Rabindranath Tagore, on *Art and Aesthetics* p. 47. "The fact that we exist has its truth in the fact that everything else does exist, and the "I am" in me crosses its finitude whenever it deeply realises itself in the "Thou Art". This crossing of the limit produces joy, the joy that we have in beauty, in love, in greatness".

8. "Verily not for the sake of the husband is the husband dear, but a husband is dear for the sake of the self. Verily not for the sake of the wife is the wife dear but a wife is dear for the sake of the self, etc. (*Brihadaranyaka Upanishad* 11.4.5, from S. Radhakrishnan, *The Principal Upanishads*, George Allen and Unwin Ltd., London, 1953.

This view of art also emerges from another basic charac-
teristic of Indian thought wherein value is attached only to
that which lies beyond the sensuous surface and phenome-
nal appearance of things. According to the school of
thought which upholds the autonomous theory of art, "in
and for itself", art performs the function of making us
aware of the sensuous immediacy of the aesthetic surface.
Daily life is dominated by practical interests, scientific know-
ledge is preoccupied with abstractions, and because of the
pressure of both we cease to attend to the sensuously given
for its own sake, it is argued. The artist's main purpose is
to present to us in an arresting way the sensuous aspect of
an experience, to isolate and abstract it from the environ-
ment so as to give the full impact of its content in a pure
undiluted manner. Thus the artist's function becomes
merely that of drawing our attention to what we may other-
wise fail to notice for instance, the fresh brightness of a
spring morning, the heat of a summer day, the poignancy
of a lover's plaint etc.

This extreme view which is the natural conclusion to
which the "art for art's sake" theory must lead has been
explicitly stated by D. W. Prall in his work *Aesthetic
Judgement.*

"Discriminating perception focused upon an object as it
appears directly to sense, without ulterior interest to
direct that perception inward to an understanding of the
actual forces, or underlying structure giving rise to this
appearance, or forward to the purposes to which the
object may be turned, or the events its presence and
movement may presage, or outward to its relations in
the general structure and the moving flux such free atten-
tive activity may fairly be said to mark the situation in
which beauty is felt. It is the occurrence of such activity
that make possible the records put down in what we
have called aesthetic judgements."[9]

9. D.W. Prall, *Aesthetic Judgement,* quoted in Susanne K. Langer,
 Feeling and Form, Routledge and Kegan Paul, Ltd., London 1967,
 p. 55.

Prall goes on to elaborate on the nature of pure aesthetic qualities which are made available to us through the isolation of their sensuous content. Elements in their own intrinsic nature and in their relationship to the feelings of pleasure and displeasure of the perceiving subject.

There is no doubt that the presentation of aesthetic surface is an essential function of art. The pleasure-giving and life-enhancing feeling (*kama*) is one of the primary motivating forces of art since it is through this feeling that we are identified with the art-object in the first place. But the recognition of this should not mislead us into the supposition that art is nothing beyond the presentation of the sensuous. Neither should it lead us to the opposite premise, namely that the deeper meaning of art lies in its possession of an abstract intellectual content. Art is neither the pure sensuous, nor the mere intellectual, it is not philosophy, nor science or theology made attractive for the people through sensuous embodiment. The utility of art does not lie in its ability to popularise religion or scientific ideas through the sensuous vividness of its expression, nor does its utility lie in arousing passions and sentiments (suitable or otherwise), as Plato thought. The value of art lies in its ability to express the fundamental and inner nature of the actual. This statement does not refer to the expression of a psychological or psychical truth about man or to the expression of a physical truth about nature, but it refers to the creatorial office of art whereby art reveals nature's inner law and not her appearance, nature's ideal form and not her superficial aspect.

The function of the artist is to represent the creative act and not the created thing. The art symbol is a creation and not a duplication; it seeks to reveal the ideal form of things and as such its correspondence to reality is in the manner of an analogy. The art-work being the sensible manifested form of the transcendent metaphysical principle.

What is meant by saying that art reveals nature's inner law or its ideal form? While most aestheticians today acknowledge that art is something more than simple imitation or reproduction of nature, very few are aware of the

full implications of this acknowledgement. Most of the
attempts to find in the expression of art a deeper revelation
of man or nature, lead in one way or another to intellectual
theories, which hold art to be a different kind of knowledge
dealing with an area of experience other than that of science
and philosophy.[10] Or, because the artist seems to be fami-
liar with a realm of experience of which the common man
knows little or nothing he is credited with some mysterious
power to penetrate the heart of things, this power going
under the name of "individual insight" through which he is
supposed to know more than all the labours of scientists
have revealed through the ages. These theories, however,
fail to explain the true nature and purpose of art because
they do not take account of its concrete actual and creative
function, whereby it is a means of relating human life to the
creative cosmic life, to the essential vitality and movement
which underlies the universal system. The artist discovers
this universal creative process by an actual participation
and essential identity of experience. Kuo Jo-hsu, the Chinese
painter of the 12th century, said: "The secret of art lies in
the artist himself."[11] The traditional artist of India, like his
Chinese counterpart, lived close to the creative life of nature
and tried to relate his work to its movement and inner laws
(*chandas*) rather than to its appearance. The first canon of
classical Chinese art is "rhythmic vitality."[12]

To participate in and to recreate the cosmic dynamism is
the essential function of art, and all other effects which
accompany this process inevitably or incidentally are sub-
ordinate to it. A work is not truly artistic if it does not
express the inner rhythmic vitality of the represented
object.

The conditions of art are also the conditions to which
human life must conform if it is to attain to the fulfilment
of its own inherent possibilities and in doing so attain to
its fullest possible measure of communion with the life of

10. Otto Baensch, quoted by Susanne Langer in *Feeling and Form*, p. 19.
11. *cf.* James Cousins, *The Faith of the Artist*, p. 60.
12. *ibid.*, p. 60.

the universe. From this close collaboration between the artist and the object, and between the artist and spectator, comes the experience of perfect pleasure not only for the artist but also for the spectator as both respond intimately to the qualities of rhythmic proportion, harmony, texture, movement of things. These are what the Indian texts refer to as *chandas*.[13]

The artist is expected to express the creative process and not the created "thing". Every work which purports to be an example of art, must exhibit this process, underlying the appearance of things and that which is not revealed by the outward aspect of the words. The similarity between art and nature as Aristotle pointed out, is a similarity of the working process.[14] Call it what we may, the significant point to bear in mind is that it is not revealed through an understanding of nature's superficial appearance, but through an intuitive grasp of her inner working. As such beauty is akin to truth, a relationship which was discovered not only by Keats in his dictum "beauty is truth", but has occurred in one way or another, to most philosophers. According to Hegel, art aims at presenting "in forms for the imagination features of the ultimate ideal of the harmonised universe."

Idealistic as this theory of art may appear to be, it is, in the ultimate analysis, realistic.[15] The idea of "an essential

13. *Chandas* refer to the natural laws that sustain nature and which are known to the experimental sciences as rhythm, cadence, proportion, balance etc.

14. S.H. Butcher, *Aristotle's Theory of Poetry and Fine Art*, Indian Edition, Delhi 1964. "Imitative art in its highest form, namely poetry, is an expression of the universal element in human life" (Poetics, ix, 3) Butcher's own comment is as follows : "If we may expand Aristotle's idea in the light of his own system, fine art eliminates what is transient and particular and reveals the permanent and essential features of the original. It discovers the "form" towards which an object tends, the result which nature strives to attain but rarely or never can attain. Beneath the individual it finds the universal". p. 150.

15. *ibid.*, "The real and the ideal from this point of view are not
(*Contd.*)

form", or "archetype" which it is the artist's function to reveal in his work, does not stem from an abstract desire to understand the world process as scientists do, but from a concrete and biological impulse to identify oneself with the cosmic rhythm and to participate in the essence of being. It is this psychophysical desire for an active communion between man and nature, which makes it possible for man to direct his thought and creative expression to an end beyond himself and to supply the *raison d' etre* for art from causes lying beyond the work itself.

Sukracarya, the reputed author of the *Sukranitisara* a late medieval work on art, politics and science but harking back to older traditions, enjoins the artist to attain to the "images of the gods by means of spiritual contemplation only. The spiritual vision is the best and truest standard for him. He should depend upon it and not at all upon the visible objects perceived by external sense."[16] This point is admirably illustrated in the earlier Brahmanical and later Buddhist sculptures. Here the male form is taken, not as an example of physical beauty, but as the material manifestation of the universal spirit, and the female becomes the concrete expression of the power of the spirit (*shakti*) "Instead of an Aphrodite or Pallas Athene, Indian art creates a *Sarasvati* Divine wisdom—or *Prajnaparamita*, her Buddhist counterpart, and *Tara* the spirit of Infinite Mercy."[17]

(*Contd.*)

opposites, as they are sometimes conceived to be. The ideal is the real but rid of contradictions, unfolding itself according to the laws of its own being, apart from alien influences and the disturbances of chance", p. 151.

Realism to the traditional Indian artist has a different meaning from what the European artists attach to it. The term is moulded by the Indian philosophical view which regards all that we see in nature as illusive phenomena, fleeting sensations, and attaches permanent value only to the Divine Essence. This is the only reality. Indian artists strive to depict through imagery something of the universal, the Eternal, and the Infinite, whereas European artists concern themselves with the sense and form of their phenomenal environment.

16. E.B. Havell, *Indian Sculpture and Painting*, London, 1908, p. 54.
17. *ibid.*, p. 51.

These objects of art do not like their European counter-
parts, represent idealised human forms, or try to create an
image of Divine Power, but they concentrate wholly within
themselves the tremendous force and majesty of cosmic
law, as revealed to the awareness of each individual. Tra-
ditional Indian art at its best is highly imaginative, em-
bodying a profound intensity of feeling, a wonderful sug-
gestion of elemental passion which transcends all human
emotions and reveals the essence and form of things.[18]

In a lucid analysis of those Indian art forms which
combine "man-animal" shapes and "man-plant-life shapes"
Stella Kramrisch explains how the artist is able to repre-
sent in terms of visual imagery the inherent coherence
between man and the cosmos. The well-known image of
Ganesha, for instance, which combines an elephant's head
and a man's portly body is the visible form of the realisation
expressed in the dictum "that thou art", the word "that"
standing for the macrocosm and the word "thou" for man
the microcosm. "In the conjoint image, the shapes inter-
penetrate. The limbs of man become elephantine in their
proportions, the shape of the one component of the con-
figuration being raised to the power of the other."[19] The
coherence of man and the universe expressed in this and
similar images, represent on the higher plane of reference
the coherence of "this manifest cosmos with the stage be-
yond manifestation. The entire shape presents itself as a
single visual unit, it emanates consistency and power which
even those who are not familiar with the background of
Indian thought can feel."[20]

It must be noted in this background that the concept of
"form" is in Indian thought quite different from Plato's
"universals". This distinction provides also the chief
difference between the autotelic theory of art as developed
by the main body of Western aestheticians, and the so-called

18. *ibid.*, p. 62.
19. Stella Kramrisch, "Indian Sculpture", in *The Philadelphia Museum of
 Art*, Philadelphia, University of Pennsylvania, 1960, p. 15.
20. *ibid.*, p. 15.

functional approach of Indian aesthetics. First, there is no dissociation between form and sense in the Indian concept, and therefore, the types referred to here are those of sentient activity or functional utility, conceivable only in a contingent world, whereas Platonic types "are types of being, external to the conditioned universe and thought of as absolutes reflected in phenomena.... Oriental types, Indian Shiva-Shakti, Chinese Yang and Yin or Heaven and Earth, are not thought of as representing to our mentality the operative principles by which we explain phenomena."[21] "Forms" in the Indian sense, are never "abstract" but on the contrary, things which can be described as "sensible" since from their point of view, subjective and objective are not irreconcilable categories one of which must be regarded as real to the exclusion of the other. Reality (*sat*) is an identity of thought and being (*cit*) of the ideal and the actual, the intelligible and the sensible. Knowledge itself is the art of knowing, feeling and being; truth does not exist as an abstract, objective principle, without it being immediately apprehended. According to St. Thomas, "Knowledge comes about in so far as the object known is within the knower."[22]

Art is the principle of manifestation of form, and the function of the artist is to apply the cosmic laws to the domain of forms through which the general style and tradition of the age is revealed rather than the arbitrary creation of the individual. These artistic forms being concrete and not abstract, possess a universal quality by corresponding directly to the principled order of things; they act as indispensable channels for "the actualisation of the spiritual deposit of the tradition."[23] As such they are of no small value to the development of the higher faculties of man, and far from engaging the superficial aspect of his personality

21. A.K. Coomaraswamy, *Transformation of Nature in Art*, p. 17.
22. *ibid.*, p. 11.
23. Frithjof Schuon, "Concerning Forms in Art", in *Art and Thought*, Iyer, K.B. ed. 1947, p. 6

these artistic forms are closely bound up with the deepest
realities of human existence.

The functional aspect of art stressed in Indian tradition-
al culture, has its roots not in any abstract desire for know-
ledge or sensuous desire for pleasure but in ritualistic reli-
gion wherein ornamentation of weapons and instruments
was rendered for the sake of the power it could exercise on
the unknown forces, rather than the knowledge of reality it
could grant, or the delight it could afford to the senses. In
a study of the relationship between art and religion, Jac-
ques de Marquette tells us; that the study of primitive
societies has led anthropologists to demonstrate that most
art forms owed not only inspiration but their very inci-
piency to religious ideas.[24] He further tells us how the
efficiency of magical rites as a means to compel natural
forces, gave way to the worship of religion. "Thus an ope-
rative technique turned into *rogatory orison* ultimately to
reach pure worship."[25] It can however be argued that the

24. "The first drawings on weapons or tools were destined to increase
 their efficacy by conjuring the support of totemic influences, suscepti-
 ble of strengthening the *mana*, the magic power of the operator".
 The instruments become more effective and powerful when the magi-
 cian "through the compelling designs he carved on their surface, had
 endowed them with a means of connection with, and participation in
 the great store of magical power which was the origin of all practi-
 cal efficacy. This was brought about because of the correspondence
 between a transcendent power and the graphic representations of its
 ideal form". Jacques de Marquette, "Art to Spirituality" in *Art and
 Thought*, op. cit., p. 23.
25. *ibid.*, p. 24. Also E.B. Havell, *Indian Sculpture and Painting*, Lon-
 don, 1908, p. 25: "Indian art is essentially idealistic, mystic, symbolic
 and transcendental. The artist is both priest and poet. In this
 respect Indian Art is closely allied to the Gothic art of Europe; in-
 deed, Gothic art is only the Eastern consciousness expressing itself
 in a Western environment. But while the Christian of the middle
 ages is always emotional, rendering literally the pain of mortification
 of the flesh, the bodily sufferings of the man of sorrows, Indian art
 appeals only to the imagination, and strives to realise the spirituality
 and abstraction of a supra-terrestrial sphere.

 There is and always will be, a wide gulf between these ideas and
 (*Contd.*)

use of ornamentation and design on instruments constitutes no proof of the religious origin of art and that the impulse to artistic expression is due to an entirely different source of human motivation, such as the innate desire for self-expression, for play or simply for pleasure. It is not our purpose to go into the details of the arguments generally extended in favour of one or the other position, but merely to point out the basis upon which the traditional view of art is set up and which has been the main view held in India till modern times. Whatever may be the other differences between art and religion, they rest, as we have said already, on the fundamental notion of an intimate and immediate connection between man and the universe, that connection being in the nature of a participation in the one essence of being. It is the belief in this essential identity that leads man either through work, worship or knowledge to direct his thought towards the essence of being and realise it within himself.

This purpose of art is the very highest and is hence linked closely with the religious motive. It is not implied thereby that art is simply a tool in the service of religion but that the urge for both arises from the same spiritual nature of man and from his aspiration to realise himself in and as the object of worship (creation). Both art and religion having the same motivating force and using the same material, that is, the volitional, imaginative and emotional faculties of man go hand in hand in helping each other, serving each other, even borrowing some disciplines and practices from one another. Yet the two are independent functions; they are, as pointed out already, twin brothers, born from the same source but else quite distinct.[26] Indian *alamkara* and *silpashastra* texts while emphasising the spiritual quality of art and borrowing from religion some of

(*Contd.*)
 the naturalistic, materialistic view of the Renaissance, or the eclectic, archaeological art of modern Europe—the cult of the studio, the lay figure, and the nude model."
26. See Introduction, note 18.

its rituals and disciplines designed to enhance concentration, single-mindedness, a calm mirror-like mind, and other preliminaries which help to bring about a sensitive and receptive state of mind, nevertheless mark clearly the defining boundaries between the religious and the aesthetic consciousness. The earliest perhaps to draw attention to this point was Bhatta Nayaka who observed the similarity between the delight afforded by the contemplation of an art work, and the beatitude of ecstacy or the experience of Brahman. The artist and the *yogin* both experience in the final moment, an unbounded joy (*ananda, rasa*) which converts *samsara* into *nirvana*. This conversion of pain into pleasure is the essence of both the religious and the aesthetic experience. To both belongs that exclusive state of mind freed from all obstacles, such as pain, disquietude, desire etc., which transfigures the objects and experiences of daily life and which is self-contained, compact, pure. In fine, both experiences are characterised by the predominance of the *satvikaguna*, which means that they are both free from the passions, emotions and interests of daily life and belong to the state of contemplative quietude.

While apparently the same, there is yet an important difference between the two which Abhinavagupta was later to stipulate. Religious experience, he says, is a move away from life. It marks the complete disappearance of all differences and antagonism; the devotee abandoning all to the object of worship, seeks to forget the things of life and tries to identify himself with the transcendental. "Religious devotion implies therefore a constant drive towards an end which is outside it and as such is the very antithesis of aesthetic experience which is perfect self-sufficiency."[27]

In the aesthetic experience the subject-matter is borrowed from daily life and even though it be transformed it is never forgotten but ever present While the worshipper of God tries to forget life, the artist is fully conscious of its every element. Aesthetic delight never reaches that state of oblivion and self-forgetfulness that characterises spiritual

27. Gnoli, *The Aesthetic Experience*, op. cit., p. XXV.

ecstasy, though in fleeting moments the artist does become aware of it. Hence the aesthetic moment is clearly a state of pure joy (*rasa*) and not of total spiritual liberation (*moksha*). In the former are the seeds of the latter, it is a modality of the highest unfettered state but not identical to it.

The famous definition of the aesthetic experience given by Visvanatha in his *Sahitya-Darpana* is similar to the conception of Abhinavagupta and Bhatta Nayaka. He says "*Rasa* is tasted by qualified persons. It is tasted by virtue of the emergence of *sattva*. It is made up of full Intelligence, Beatitude and Self Luminosity. It is void of contact with any other knowable thing. Twin brother to the tasting of Brahman, it is animated by a *camatkara* of a non-ordinary nature. It is tasted as if it were our very being in indivisibility".[28]

Another fundamental difference which suggests itself in connection with the two experiences, the religious and the aesthetic, is the permanent nature of the religious state and the transitory nature of the aesthetic moment. Despite these real differences the underlying similarities of the two states are sufficient to afford the artist, the practical benefits which make art, despite its self-sufficiency, a means for the higher development of personal qualities and thereby a moral activity.

From this we can conclude that art has really a two-fold function. On the one hand the experience of pure delight is sought as an end in itself, on the other the very experience is used as a means to the attainment of a higher state. In the first case art is an autotelic activity, in the second it pursues an end beyond itself leaving its self-sufficient realm to enter that of life, itself. The latter approach is summed up unequivocally in the statement of the *Sahitya-Darpana* (V.I) already quoted above : "All expressions, human or revealed are directed to an end beyond themselves, or if not so determined are comparable only to the utterances of a mad man." The former view is implied in the theory of *rasa* wherein the soul of poetry is said to be enjoyment alone, and the function of art is to afford delight.

28. *ibid.*, p. 55 note. Also Cf. Chap. I.

Paradoxical as this two-fold function may seem to be, it does not offer a contradiction; in fact it reconciles the opposing claims of art and morality. The aesthetic state of pure delight, evoked solely by the artistic qualities of the work and not by any extra artistic considerations is essentially a good state.[29] No other qualities need be taken into account, for artistic qualities alone are as great a means to good as any other. The relationship between art and morality is only in this very broad sense the business of the artist. Art is a moral means to an end because it leads to a good state of mind and being. By fulfilling itself art fulfils simultaneously the highest function of mankind, the liberation of the individual from the narrow confines of its passion-bound ego. Art pursued for its intrinsic qualities is the most direct and potent means for the exaltation and purification of the individual.

The pursuit of art for its own intrinsic ends should not however lead to the doctrine of "art for arts sake" as it is generally understood, wherin the presentation of aesthetic surface and aesthetic form is divorced from the deeper meaning of life and human purpose, and is sought for itself alone. Such a concept is abstract and sterile. The complete and proper pursuit of art implies simultaneously the pursuit of those qualities which are valuable for life and for the spiritual development of the individual. The true aesthetic attitude is the result of a total self-abnegation on the part of the artist and the consecration of his work to another in the spirit of a devotee. It is through an act of will as much as through an effort of imagination that the artist creates. He who is devoid of this almost religious attitude, is merely a skilful virtuoso, an adept or simply a practitioner of art, one who pursues it as a hobby or a vocation, but not according to its proper function as a means for the highest development of himself as a person.

The difference between a purely aesthetic view of art and a functional view of art lies in this; whereas the former

29. By "good" is meant, in accordance with Indian theory, that which leads to greater enlightenment and happiness.

aims at transforming the material of art alone the latter
seeks at the same time to transform the artist. The aes-
thetic is used here as an aid to contemplation, it stands not
on its own but has its life in a living metaphysic.

In the beginning of this chapter we said that the func-
tion of art is justified inasmuch as it subserves the four
ends of life viz., right action, satisfaction of desires, acquisi-
tion of wealth, and spiritual freedom. When it subserves the
goal of spiritual freedom, it is linked intimately with meta-
physics and religion. Devoid of metaphysical meaning art
breaks loose of the true creative source; when, however, art
pursues the proximate goals of life it is linked intimately
with the social order. Devoid of social content and mean-
ing, art becomes a kind of eccentricity and not a human
necessity. It fails to provide that fulfilment which inte-
grates human personality within the larger social context.
It is to this aspect of art, we must finally turn.

EIGHT

Art and the Social Order

IN THE previous chapter we noted that one of the main functions of art lay in the positive ethical value provided by it in the life of the individual, a value which did not accrue to it from any extra aesthetic causes but stemmed from the very nature of the art activity itself. In this chapter we wish finally to emphasise art as a function of the social order and its value to society thereof. The discussion will also include allied questions such as the extent to which the artist is free within the social context. Should he permit himself to be influenced by his cultural environment? Does he, as an artist, owe a responsibility to society and to its members? If so, in what way?

The traditional Indian theory of art assumes an integral relation between art and society.[1] This assumption is based naturally on their comprehensive understanding of the term 'art' which is for them not a particular kind of activity relying on the "vagaries of genius" but a highly disciplined method depending largely on training. Through this method everyone (genius or otherwise) is able to achieve a desired result. In other words, it is simply the systematic

1. Ananda K. Coomaraswamy, *Christian and Oriental Philosophy of Art*, Dover Publications Inc. New York 1956 p. 27. "In our traditional view of art, in folk art, Christian and Oriental art, there is no essential distinction of a fine and useless art from a utilitarian craftsmanship. There is no distinction in principle of orator from carpenter, but only a distinction of things well and truly made from things not so made and of what is beautiful from what is ugly in terms of formality and informality."

and organised employment of energy and skill towards the fulfilment of human purpose and as such is not confined to a special group of people who alone are considered competent to practise art. In fact, it is a discipline which can and should be imbibed by everyone. Philosophers have a similar idea in mind, when they declare art to be human intelligence.[2] Taken in this very wide sense art includes the whole of life. Now, a complete civilisation is one which is based on organisation and system. Life in such a state would automatically be coincident with art,[3] and the arts of the statesman, artisan, physician, lawyer, etc., would be given therein the pre-eminence that goes to the arts of music, dancing, painting and sculpture, and the fine arts would be created to serve social ends.

The point of difference between this approach typical of the Indian point of view and other art theories lies basically in its refusal to isolate art from human purposes and to make a distinction between the utilitarian and the beautiful. "The work of art is not merely an occasion of ecstasy, and in this relation inscrutable, but also according to human needs and therefore according to standards of usefulness, which can be defined and explained."[4] In this context art is human necessity and not a mere playtime activity. It is the fulltime expression of a healthy civilisation and not the passing fad of a leisured class. It belongs to mankind in general and not only to a small privileged group of people who label their idiosyncracy as art. In fine, art is not an exclusive cult the object of which is to pursue the remote

2. Irwin Edman, *Arts and the Man*, W.W. Norton & Co. Inc. New York, p. 36.
3. *ibid.*, pp. 36-37.
4. Mulk Raj Anand, *The Hindu View of Art*, App. I *The Philosophy of Ancient Asiatic Art*, by Ananda Coomaraswamy, Asia Publishing House, Bombay 1957. "This good or usefulness will be of two main kinds : religious and secular; one connected with theology, adapted to the worship and service of God as a person the other connected with social activity adapted to the proper ends of human life which are defined in India as vocation or function (*dharma*), pleasure (*kama*) and the increasing of wealth (*artha*)."

ideal of beauty, but a normal, healthy, intelligent activity distinguished from the ordinary by the high degree of organisation, system, discipline and training that is required. Beauty accordingly is not an inaccessible value abstracted from life but lies in the perfect functioning of the work, that is, in the complete working of the purpose for which the work is made. This view presumes that every object is made for some purpose and not simply for decoration and exhibition. When it is made for use, a work of art is subject to certain requirements, individual and social, and hence considers its relationship to its ultimate surroundings. It becomes then an integral part of the entire social complex and does not remain a phenomenon isolated from it. Artists are accordingly socially responsible beings, securing human aims and not society outcastes, or according to the trend-in-vogue, society idols. An object which is made to suit the inclination of the artist and not the requirements of society is a kind of oddity and curiosity, and not art.[5] Since it is made without any purpose in view it becomes an accidental form of self-expression rather than a carefully planned and organised work.[6]

Indian art theory like the medieval scholastic theory of art in the West, emphatically denies the view that makes art a curiosity; for the Indian theorists it is a perfection in making as ethics is a perfection in doing, and the artist is one who has understood the principles of proper making and learnt how to apply them with adequate skill.[7] Consequently there is no substantial difference

5. Cf. Jacques Maritain, *Art and Scholasticism*, tr. J.C. Scanlan, Charles Scribner's and Sons, New York, 1943, pp. 32-35.

6. "Art which is only intended to be hung on the walls of a museum is one kind of art that need not consider its relationship to the ultimate surroundings. The artist can paint anything he wishes, any way he wishes and if the curator and trustees like it well enough they will hang it up on the walls with all the other curiosities." Steinfels, quoted by Ananda K. Coomaraswamy in *Christian and Oriental Philosophy of Art* p. 8.

7. This view is similar to the medieval Christian view where art belongs to the practical order. Its orientation is towards doing, not to the
(*Contd.*)

between the vocational worker and the artist. This aspect of the art activity is often overlooked by those who in their anxiety to place art on a pedestal and elevate it above other activities, emphasise purely its mental aspect and neglect to take account of its application in practical life. Art thus, in order to justify its existence in everyday life assumes a superficial role. Some declare its very function to be "uselessness", and if this leads to a rift in society between the useful and the beautiful, justify the isolation of the latter by the well-known cliche that "Art bakes no bread but it nourishes the soul."[8] A rift, is therefore, created (1) in the social order, between two different classes of activities, the utilitarian and the artistic with all that is dreary, monotonous and stultifying characterising the former, and all that is pleasurable, characterising the latter and (2) in the human personality between two different faculties, the practical and the mental with no possible connection existing between the two. This rift presumes a dual function of the individual whereby he is motivated by opposing forces and desires. On the one hand is the work he undertakes for his physical and material well-being in which no element of beauty or joy must enter, and on the other hand is the hobby he pursues for his mental and spiritual well-being and in which

(*Contd.*)

pure inwardness of knowledge. The Scholastics make a sharp distinction between making which belongs to the sphere of art and doing which belongs to the sphere of ethics. Metaphorically the whole of life can be said to be an art i.e. the art of living in true perfection; this art the saints alone fully possess. It may be compared to the Indian concept of the *jivanmukta* that is, the man who lives in perfection, fully enlightened and hence has no more need for art or morality. The sharp distinction made by the Christian Schoolmen between art and prudence is not clearly defined in the Indian theories, but implied by them. Both art and morality subserve the final goal of self-realisation.

8. This view was accentuated in the nineteenth century, when as a result of the reflections of such men as Dubos, Vico, Kant, and Schiller who developed a separate philosophy of art, the view that art has a unique nature and function came to be associated with the so-called theory of "art for art's sake."

pursuit no element of utility or labour must enter. Beauty, it is held, by those who support this theory, must be pure and totally *free* of all restrictions.

The cause of this unnatural cleavage between art activity and the practical concerns of life is not difficult to trace. It has two main causes : (1) an inadequate understanding on the part of the artist of ultimate human goals and purposes and (2) socially inadequate conditions which compel the individual to seek fulfilment in superficial activities rather than in the essential.

The art impulse of mankind is predominantly an expression of the ideas, aspirations and thoughts of the age in which it is nurtured. When a relatively more materialistic view of life predominates as against religious and spiritualistic view, art becomes primarily a medium for providing sensuous pleasure and the artist's main emphasis lies in presenting pleasing and decorative forms to the eye rather than those which are spiritually elevating. The aim of art becomes in this case the mere exhibition of aesthetic surfaces and often no distinction is made between the amusing, the provoking, the emotionally stimulating object, and the artistic object. The only criterion the work of art is expected to conform to, is to its capacity to please.

Those aestheticians who would justify this view of art and save it from degenerating into a philosophy of pure hedonism, justify it on the grounds that while the main function of art is no doubt to provide pleasure, it is a different *kind* of pleasure from the ordinary. Terms like "mental pleasure", "objectified pleasure", "ecstacy" are used to distinguish the latter from the former. The attempt to distinguish the different *kinds* of pleasure that art provides, from that which is provided by other activities is justifiable in itself. It generally results however in isolating from life not only the pleasure, but the art activity which produces it as well. Since the pleasure provided is unique, the art activity which gives rise to it must also be unique, it is argued. Consequently art is removed from the ordinary affairs of daily life and elevated to an extraordinary realm. That which serves the mundane purpose of providing utilitarian

goods cannot be artistic, nor give rise to the aesthetic plea-
sure. Art and utility cease to function together, the former
withdrawing into the limited sphere of pure art, the produc-
tion of utilitarian goods becomes merely mechanical design-
ed to sell easily rather than to satisfy the creative urge. In-
stead of goods becoming beautiful and functional at the
same time, they are either beautiful or functional. Instances
of the former are confined to what are commonly called
pure or fine art, such as "a sculptured horseman among the
Elgin marbles, a Greek temple shining by a Sicilian sea, a
lyric by Shelly or a quartet by Schubert."[9] The argument
in their favour goes like this. "These things seem to have
their own unquestioned charm. They bake no bread but
they feed the eye or the eye of the soul. They stir the sen-
ses to action and the imagination to pleasure and the mind
to delight. They are good because they are good for nothing
except their own immediately charming selves. Such value
as they have is to be reckoned not in terms of the utilities
they produce but the immediate sensuous and imaginative
satisfaction they provide—for the colours, shapes, sounds
and suggestions they are."[10]

This argument, persuasive as it is, loses sight of the pri-
mary function of art, which is not to provide pleasure, intel-
lectual or otherwise, as an end in itself but to act as a syste-
matic means for the achievement of human goals. Pleasure
or aesthetic delight (*rasa*) is an invariable and necessary
accompaniment of this achievement but cannot be pursued
for itself. In other words beauty is an essential aspect of
truth and goodness and not an autonomous value existing
for its own sake. It is for purposes of discussion alone that
beauty is considered in isolation. In fact as already men-
tioned beauty as a value is synonymous with the perfect
working out of the ends for which men work.

Historically we find that the isolation of art from society
has been due to the urge to save art from the mechanisation
and mere utilitarianism to which it degenerates in those

9. Irwin Edman, *The Arts and the Man,* p. 39.
10. *ibid.,* p. 39

periods when the materialistic view of life dominates, that is, when considerations of profit and other motives dominate rather than the good of the work itself.[11]

An instance of "mere utilitarianism" is provided in modern times by the emphasis placed on high profits and mass production of goods in industry rather than on the good of the work. Accordingly today men prefer to take jobs which provide great income and profit even though the means of production are mechanical and repetitive rather than vocational. This condition has been aggravated by an industrial and technological society dominated by the laws of economics wherein responsibility rests only upon those who can produce the maximum goods for the maximum gain. As for those who wish to create also for the sake of beauty, they are forced to confine their work to the production of articles that have no use in life.[12] The cult of beauty without responsibility is a reaction against a responsible life

11. Jacques Maritain, *Art and Scholasticism*, p. 35. "The good of the work does not mean the pursuit of art as an end in itself but the functional considerations for which the work is created rather than the moral ends which lie beyond the work."

12. De Wilt H. Parker, "The Nature of Art", reprinted in *The Problems of Aesthetics*, Vivas and Krieger, Holt Rinehart and Winston, New York, 1963, p. 98. "The industrial arts have always proved to be stumbling blocks to aesthetic theory. Is it said that the field of art is mere appearance, unreality, illusion : well, what is more real than a building or a pot ? Or, is it said that beauty has nothing to do with utility: well, is it not obvious that fitness of form to function plays a part in the beauty of pots, baskets, houses, and the like? The only way to solve the difficulty is to recognise that the practical meaning as pure meaning does enter into the aesthetic experience of such things. It is of course true that the aesthetic value of a building is not the same as its practical value : one does not have to live in it or own it in order to appreciate its beauty. Or one does not have to wear a shoe in order to know that it is beautiful : "window shopping"— a good example of imaginative satisfaction—proves that this is so. The aesthetic value is a transfer of the practical value to the plane of imagination.

"The beauty of the shoe is in the way the shoe looks, not in the way it feels, but it must look as if it would feel good. So the beauty of the house is not the living well in it; but the way it looks

(Contd.)

without beauty. In the forms of art the emancipated spirit
may find the satisfaction that is denied to it by a civilisation
without form or a universe conceived as without mean-
ing."[13]

In traditional societies on the contrary the motive for
production is generally the good of the work itself and the
good of the artist. Consequently the division between utili-
ty and beauty is less acute.

"There are half a dozen museums in Europe which have
whole galleries filled with the delicate paraphernalia of daily
Greek life—vases, spoons, combs, jars and shields. These
things were all made for use; they were intended to serve a
function. But to the nostalgic eye of the modern it is not
their function but their decorative perfection that is of first
interest. We see almost purely as things of beauty what to
the Greeks who employed and to the Greeks who made
them were things of daily use."[14] This statement applies
equally well to Indian traditional art. The temples and
places of the past were intended for habitation of the gods
and men and the decorations upon their walls were for the
purpose of enhancing faith and devotion. The outward
manifestations helped men towards a true inward realisa-
tion. In an age which was predominantly religious the
sculptures and murals of Indian art were the expressions of
a given social order and a given civilisation.[15] What are

(Contd.)
 as if one could live well in it. It is in the memory or anticipation
 of its service—twin phases of imagination—that its beauty resides.
 The use is in action; the beauty in the pure meaning. The recogni-
 tion that the practical meaning, as a pure meaning, may enter into
 beauty of an object thus solves the paradox of the industrial arts,
 and reconciles the contention of those who insist on the connection
 of art with life, with the disinterestedness of beauty proclaimed by
 the aesthetes and the philosophers."
13. Irwin Edman, Arts and the Man., p. 43.
14. ibid., p. 41.
15. Eric Gill, Art and Reality, reproduced in Hindu View of Art by Mulk
 Raj Anand. "And strange as it may seem painters and sculptors were
 not very great dukes even in medieval Europe or India. The great
 (Contd.)

now exhibited as curiosities once used to serve the needs of men. Even the traditional Indian music and dance forms, which are now performed in concert halls and theatres for the aesthetic delight of passive audiences were originally active forms of religious worship. The *Bharata Natyam* South India's best known classical dance form, was till a few decades ago primarily a temple-dance and classical music in India is permeated with the devotional spirit. Dance and music as forms of entertainment in India really gained prominence during the Muslim rule wherein these arts were developed in the courts of kings and emperors, away from the people. It is this isolated and limited sphere of art that has been condemned by moralists and philosophers both in India and the West, from Plato onwards. The stress on the purely pleasurable aspect as against the functional has always seemed a distraction to men intent upon the serious concerns of alleviating the disorders and distresses of human life and a sensuous disturber of the spirit. For Plato the fine arts were dangerous panderers to emotions and if not kept in control could disrupt the order of things and divert men from the truth of reality. Moreover, music could mould the emotions of men according to its martial or soft quality. Other moralists such as St. Augustine in the West, the Buddhists, and other puritan sects in India, have condemned the sensuality to which the arts might turn men. They have been conscious of its physical surface value which arrests the attention and leads the mind away from the inner and permanent value of things.

(Contd.)

> works of those ages also were great communal efforts. There was no such thing as a school specially devoted to the learning of a thing called art. Buildings and workshops were their art-schools, and the ideas to be expressed, made manifest in material, were not specially those of the workmen but, as today in the case of science and mechanics, of whole populations. Individual prowess was doubtless applauded, but it was seen in right perspective—a thing of small importance compared with the right-thinking of the community. A medieval cathedral, like the Quebec bridge or a common microscope, expresses the genius of a people".

Those who condemn the arts of poetry and literature do so on the grounds of their highly sensuous appeal and the irresponsible use made of this attractive media for unethical purposes, such as the provocation of revolutionary thinking and propaganda.

The above objections and others similar to them, made by practical men, politicians and moralists against the impracticality of art is understandable. For them art is an indulgence and not a necessity.[16]

It is clear that people who object to art on these grounds reflect the indignation of the whole man against an unnatural split in the human personality and in the integrated social structure.

The moralist who objects to art is really objecting to a kind of art which is used as a stimulant only for excitement and entertainment. His objection does not extend to the concept of art as a disciplined and organised human activity. Even Plato who condemned the arts of the poet, painter and musician, justified a higher art, an art which includes the whole of life. The practical man is perfectly justified in accusing the artist of a self-imposed isolation from society, an abdication of all responsibility and a refusal to use art for the good of man. Those who offer a counter argument to the practical man and justify art on the grounds that though 'art bakes no bread it feeds the soul', overlook the important point that the spirit cannot be nourished in a vacuum and that to pursue art for itself and not for an end is a form of isolation. Even the spirit must find its fulfilment in things of this world. If the fine arts have come in for criticism and contempt by widely differing

16. "Men of the world, the heads of families of business, and institutions have always regarded with more than suspicion, the artist who feels no responsibility to anything save his medium, the aesthete who feels no responsibility to anything but his exquisite sensations. In a world where there is much to be done merely to keep that world going, where the cares and compulsions of affairs tax the energies and exhaust the ingenuities of the most robust and ingenious of man, the arts both in their creation and enjoyment seem fantastically trivial." Irwin Edman, *Arts and the Man.* p. 50

groups of persons, it is because they have during certain
periods been encouraged for their irrational, superficial and
individual role, rather than for their disciplined, organised
and universal role. The arts come in for severe censor
when they cease to be the earnest expression of a whole
civilisation and become the symptomatic outburst of a
special group.[17]

Undoubtedly it was a reaction against the wide-spread
infiltration of industrialisation and mechanisation into every
aspect of life that the arts, particularly in the nineties of the
last century, virtually gave up their claim to serve human
ends and abstracted themselves from society. The cause
was valid but the solution was not. The solution does not
lie in taking art away from life and putting it into museums,
art galleries and drawing rooms, but to introduce it into all
aspects of human activity and bring it back to life. In a
well ordered society the principles of art would be applied
by everyone at their daily work and not be confined to
a few aesthetes in the museum or the concert hall.
To seek for art a function away from society and to try

17. Jacques Maritain, *Art and Scholasticism*, tr. J.F. Scanlan, Charles
 Scribner's & Sons, New York, 1943 p. 32. "In the powerful social
 structure of medieval civilisation the artist ranked simply as an artisan,
 and every kind of anarchical development was prohibited to his indi-
 vidualism, because a natural social discipline imposed upon him from
 without certain limiting conditions. He did not work for society
 people and the dealers, but for the faithful commons; it was his mis-
 sion to house their prayers, to instruct their minds, to rejoice their
 souls and their eyes. Matchless epoch, in which an ingenious folk was
 educated in beauty without even noticing it as perfect religious people
 ought to pray without being aware of their prayers; when doctors and
 painters lovingly taught the poor, and the poor enjoyed their teaching,
 because they were all of the same royal race, born of water and the
 spirit.

 "More beautiful things were then created and there was less self-
 worship. The blessed humility in which the artist was situated exalted
 his strength and his freedom. The Renaissance was destined to drive
 the artist mad and make him the most miserable of men—at the very
 moment when the world was to become less habitable for him—by re-
 vealing to him his own grandeur and letting loose upon him the wild
 beast Beauty which Faith enchained and led after it obedient, with a
 gossamer thread for leash."

and create beauty without meaning and utility is to reduce art to a mere superficiality. By introducing art to serious living, the quality of disciplined spontaneity and organised pleasure is brought to everyday life and work is transformed from drudgery into a creative fulfilment. The primary function of art in society is to effect this transformation and thereby to help integrate the social order.

The main point to be noted here is that art is essentially a practical activity. While it derives its source from the imaginative visualisation of the artist and leads to the contemplative enjoyment of the aesthete, it is the external and necessary manifestation of a three way process. The aesthetic experience to which the art activity leads is undoubtedly a unique experience marked by its "away-from-life character", but the art activity itself is that which requires worldly skill and aptitude; it is the manifestation in visible and tangible form of the aesthetic consciousness. A far-fetched analogy can describe it as the body in which aesthetic joy (*rasa*) is the soul. As a tangible phenomena, art is subject to the laws and rules of society, and its making is not merely an occasion for aesthetic contemplation, but does something for human needs.

The Indian view of art places an equal emphasis on skill and training as on visualisation. The practice of art consequently becomes typically an hereditary vocation and not a matter of private choice. Artistic ability is not conceived as an inspiration, but rather in the same light as skill in surgery or engineering.

This view may seem to impair seriously the concept of the freedom of the artist, particularly as it is conceived in modern times, when the artist feels no pressures whatsoever from society and is permitted to create according to his own choice. If "freedom" in art implies the freedom to express one's self in whatever way one chooses and to 'invent' new themes the traditional view no doubt imposes a restriction. Traditional Indian art forms require the artist to work within the narrow confines of technicality and craftsmanship. Innovation for its own sake is not encouraged,

the work of art being required to conform to the strictest prescribed standards.

Admirably does Coomaraswamy sum up the total traditional approach; "The themes of art are provided by general necessities inherent in racial mentality and more specifically by a vast body of scripture and by written canons; method is learnt as a living workshop tradition, not in a school of art; style is a function of the period, not of the individual... Themes are repeated from generation to generation and pass from one country to another; neither is originality a virtue nor 'plagiarism' a crime, where all that counts is the necessity inherent in the theme. The artist as maker, is a personality much greater than that of any conceivable individual; the names of even the greatest artists are unknown."[18]

The outward restrictions imposed upon the artist are not designed to stultify and choke him, but rather to provide the guidelines within the framework of which he can achieve a more profound expression. The goal of art is not a vagrant spontaneity but a disciplined expression. Freedom in art as in any other human activity is achieved, when the universal principles are understood by the subject so completely that their manifestation in a specific form becomes effortless and spontaneous. This understanding achieved through the practice of the strictest discipline, is the result of a total identification of subject and object. What is expressed therefore is the inner spiritual "self" the essential aspect of the personality and not the transitory "self" with its passing fads and fancies. The traditional Indian artist aims at revealing through the art-work his innermost being and thereby effecting a liberation from his superficial individuality. He does not feel the necessity to express his personality through the uniqueness and novelty of the art-work. The kind of freedom which permits the artist to express the varying facets of a changing personality is not what he seeks. He does not waste his efforts in trying to evolve new art forms and modes of expression but depicts

18. Ananda K. Coomaraswamy, *The Philosophy of Asiatic Art,* reprinted in *Hindu View of Art* by Mulk Raj Anand, p. 110.

the typical because for him all art forms are conventions which when fully grasped, the artist has no need for any more. But till such time that these are properly understood they must be applied conscientiously with complete mastery. The one thing most necessary to the human workman is practice (*abhyasa*) which is not simple dexterity but a devoted application (*anushilanam*) with full comprehension of the rules, which results in an effortless second nature and finds graceful expression (*madhurya*) in the performance.[19]

Abhyasa requires complete fidelity to the prescribed canons, which can be put aside only when the artist has achieved such perfection in his work and has attained such an identification of the inner and the outer, that he works with complete accuracy and spontaneity. Such a condition is seldom achieved and when it is, the artist has no more need for art. Such an ideal is represented in Indian philosophy by the concept of the *jivanmukta*, that is one who has transcended human ends and is entirely free from motivation. In this stage the individual is beyond action, knowldege and art. It is the seldom achieved goal towards which all creation strives.

The canonical prescriptions which the traditional artist follows conscientiously help not only the artist to achieve his purpose but also help the spectator to achieve a ready identification with him. When the artist creates according to personal choice, the spectator can appreciate his purpose only if by accident he is able to identify himself with the artist's intention and theme.

A question arises regarding the symbols of art. Are they universal or culturally tempered?

The only universality that can be said properly to take place in art, is due to the creative impulse seeking expression through the eternal laws of rhythm, harmony, tension, cadence, dynamic movement, contrast etc., which are referred to as *chandas*. These laws belong not only to external nature

19. Ananda K. Coomaraswamy, *Transformation of Nature in Art*, Dover Publications, New York, 1934, p. 19; *Natyashastra*, Benares ed. XXVI, 34; *Kavyamata*, ed., XXII

but find a subjective correspondence in the emotional and intellectual life of the individual, and are expressed through the media of sounds, colour, line, movement, texture etc. The techniques, methods and conventions which an artist employs are generally confined to his age, time and civilisation. They constitute, so to speak, "the language" of art as it is expressed within a certain cultural milieu. These techniques do not restrict the artist's freedom but provide him with a medium of expression relevant to his environment. As the grammarian depends on his rules of syntax and the writer on his command of the language, so the artist depends on his techniques. These are to him the instruments through which he can communicate and express. Because the art symbol is a natural and ideal one, and not arbitrary or conventional, the "language of art", despite its cultural setting, can be more widely understood. It is nevertheless a product of the civilisation from which it springs.

To what extent is the artist responsible to society and what responsibilities must society assume towards the artist?

It is clear from our foregoing discussions that the very term artist implies a responsible human individual who produces for the good of the work and not for considerations of profit or exploitation. The artist who creates purely for pleasure and does not take account of human goals is an "idler" and his place in society is in the same category as a dreamer and a parasite. As in Plato's "Republic" we may honour such a man, but give him no place in a well-organised state. At the same time if we desire every man to be in some way an artist, that is, to work without any motive other than that of the good of mankind and of the work done, society must assure every individual of an opportunity to create according to his aptitude and ability. In other words, society must create conditions, whereby each man can choose his vocation and earn his livelihood through that activity in which he finds pleasure.

Conclusion

In the foregoing chapters, the solutions offered are by no means final or exhaustive. They are such as have been suggested in the process of explanation and analysis. Let us attempt to summarise briefly the main conclusions that emerge.

1. In the first place it is acknowledged that there is such a thing as a distinct and unique kind of experience known as the aesthetic experience. The distinction, however, does not categorise the aesthetic into an isolated realm of its own, making it a peculiar branch of knowldege and experience, but into a higher mode of being and awareness, a level which the individual attains through his own innate capacities.

2. This mode of being and awareness is the outcome of a special mental attitude which permits the observer to disengage himself from the irrelevant and existential properties of the object of perception and to identify himself, to the exclusion of all else, with its intrinsic properties. This process of a simultaneous withdrawal and identification leads to a total experience wherein the object of perception is known directly.

3. A further characteristic of the aesthetic lies in its capacity not only to bring about at certain times art experiences, but also in its transcendence at all times of phenomenal attitudes. Through this transcendence, experiences marked by the duality of a subject-object reference, gain a unitive character. The scholar, the saint and the man of action need the aesthetic attitude as much as the artist, in order to lead a full and integrated life. In the ultimate

analysis beauty, truth and goodness are three aspects of the same thing.

4. Therefore, in order to bring about an aesthetic experience, which is the same as acquiring a deeper and broader perception, a transformation is required not only of the aesthetic object during the process of art creation, but equally of the perceiving subject. The Indian theory of art, in contrast to modern theories lays as much emphasis on the cultivation of the artist's or aesthete's personality as on the mastery of the external laws of art creation. A true aesthetic experience involves a metamorphosis of the entire personality; consequently it is akin to a religious experience.

5. It follows from this, that art which is an externalisation of the aesthetic attitude is a total human activity engaging every aspect of life, and is not only confined to the making of specific objects. Broadly defined it is the employment of energy, towards the achievement of a disciplined and organised result. As such the art of the shoe maker is equivalent to the art of the painter or musician. An individual does not become an artist because of the trade he pursues, but by virtue of the method he employs.

6. The emphasis on inner phenomena for the aesthetic attitude and creative process, gives no doubt the traditional Indian theory a metaphysical and idealistic basis. But at the same time Indian aesthetics is not antagonistic to a realistic and naturalistic explanation. The concept of *rasa* for instance which signifies not only the essence of the aesthetic experience, but also that principle in art works which distinguishes them from other objects, permits fully of a natural explanation. It is the term used for the quality which emerges from the organic structure of the work of art, that is from the physical elements related to each other in a certain way. It is the unexpected and sudden appearance of *rasa* as an overpowering perceptual illusion which tends to give it a transcendental basis and make it appear disconnected with the tangible elements of the work of art. The sudden emergence of *rasa*, however, is in conformity with psychological causation and has some similarity with

Gestalt of modern psychology. Similarly the term *dhvani* which explains the nature of poetic meaning by suggesting that it lies essentially in the overtones and resonances rather than in the literal meanings of the words, is not opposed to a naturalistic conception.

7. Nonetheless if the overall aim of Indian art and aesthetics is considered to be predominantly religious, it is due to the emphasis laid on the development of inner attitudes and mental processes and to the artists final aim to lead the mind of the spectator away from the superficial, particular and transitory aspects of the work of art, towards its deeper intrinsic and universal qualities. Traditional Indian artists always sought through the expression of a universal symbolism to achieve inner peace, serenity and oneness with nature; this is in contrast to the generally accepted secular aim of modern art wherein the artist feels he is nearer to truth by expressing his own personality, with all its moods of frustration, anxiety, discontent, mockery, rejection, and resentment, or by presenting purely sensuous or formal values of the art work without leading on to its deeper spiritual values. Indian art, however, is not religious in the abstract sense of being ascetic, world-negating or purely formal. It incorporates fully all the sensuousness, romance, fervour, vitality and dynamism of the phenomenal world. Its aim and function is not to reject these, but through a process of transformation, to bring them to a fuller plane of enjoyment. In this sense it has a greater pragmatic value than present day art and aesthetics. Also by aiming basically at the cultivation and improvement of the human personality it performs a valuable social function, making art an integral part of life and the social order.

Bibliography

ALDRICH, VIRGIL C., *Philosophy of Art*. New York: Prentice Hall, 1963.

AMES, VAN METER, *Aesthetic Values in the East and West*. Journal of Aesthetics and Art Criticism, Fall, 1960.

BAHM, ARCHIE J., "Comparative Aesthetics". *Journal of Aesthetics and Art Criticism*, Vol. XXIV No. 1. Fall, 1965.

_____, "Munro's Oriental Aesthetics". *Journal of Aesthetics and Art Criticism*, Vol. XXIV No. 4. Summer, 1966.

BEARDSLEY, MUNRO C., *Aesthetics from Classical Greece to the Present: A Short History*. New York: 1966.

BELL, CLIVE, *Art*. London: Chatto & Windus, 1914.

BOSANQUET, BERNARD, *A History of Aesthetics*. London: George Allen & Unwin, 1914.

BULLOUGH, EDWARD, "Psychical Distance as a Factor in Art and as an Aesthetic Principle". *British Journal of Psychology*. Vol. V. 1912.

BHATTACHARYYA, B., *Buddhist Iconography*. Oxford: 1924.

BUTCHER, S.H., *Aristotle's Theory of Poetry and Fine Art*. Delhi: Lyall Book Depot, Indian Ed., 1967.

CHANDER BHAN GUPTA, *The Indian Theatre*. Benares : Motilal Banarsidass, 1954.

CHAUDHARI, P.J., *Studies in Aesthetics*, Calcutta : Rabindra Bharati, 1964.

COLLINGWOOD, R.G., *The Principles of Art*. Oxford: Clarendon Press, 1938.

COOMARASWAMY, A.K., *Dance of Siva: Fourteen Indian Essays.* Bombay: Asia Publishing House, 1948.

_____, *Christian and Oriental Philosophy of Art,* formerly titled *Why Exhibit Works of Art ?* New York: Dover Publications Inc., 1956.

COOMARASWAMY, A.K. and DUGGIRALA, G.K., *The Mirror of Gesture* (1971) 2nd ed., New Delhi: Munshiram Manoharlal, 1970.

CROCE, BENEDETTO, *Aesthetic as Science of Expression and General Linguistic.* Tr. by Douglas Ainslie. London: 1965.

DASGUPTA, SURRENDRANATH, *Fundamentals of Indian Art.* Bombay: Bharatiya Vidya Bhavan, 1954.

DE, S.K., *Sanskrit Poetics as a Study of Aesthetics.* California: University of California Press.

DEUSSEN, P., *Philosophy of the Upanisads.* Edinburgh: 1906.

DEUTSCH, ELIOT, S., "Sakti in Medieval Hindu Sculpture". *Journal of Aesthetics and Art Criticism.* Vol. XXIV No. 1. Part I. Fall, 1965.

DUCASSE, C.J., *The Philosophy of Art.* New York: The Dial Press, 1929.

EDMAN, IRWIN, *Arts and the Man.* New York: W.W. Norton & Co., Inc., 1928, 1939.

ELTON, WILLIAM, ed. *Aesthetics and Language.* Oxford: 1959.

FIEBLEMAN, JAMES, K., *Truth-Value of Art.* The Journal of Aesthetics and Art Criticism. Vol. XXIV. No. II, 1966.

GILBERT, KATHERINE and KUHN, HELMUT, *A History of Aesthetics.* London, 1954.

GNOLI, RANIERO, *The Aesthetic Experience According to Abhinavagupta.* Roma: IS. M.E.O. 1956.

GOTSHALK, D.W., *Art and the Social Order.* New York: Second Edition, Dover Publications, Inc., 1962.

HASS, GEORGE, C.O., *The Dasarupa, A Treatise of Hindu Dramaturgy by Dhananjaya.* New York : Columbia University Press, 1912.

HAVELL, E.B., *Art Heritage of India : Comprising Indian Sculpture and Painting and Ideals of Indian Art.* Bombay : Taraporevala, 1964.

HIRIYANNA, M. *Art Experience.* Mysore: Kaivalaya Publishers, 1954.

HOSPERS JOHN, *Introductory Readings in Aesthetics.* New York: 1969.

——————————, *Meaning and Truth in the Arts.* Chapel Hill: University of North Carolina Press, 1946.

KRAMRISCH, STELLA, *Indian Sculpture in the Philadelphia Museum of Art.* Philadelphia: Pennsylvania University Press, 1960.

——————————, *Art of India: Traditions of Indian Sculpture, Painting and Architecture.* Third Edition. London: Phaidon Press, 1965.

LANGER, SUSANNE, K., *Feeling and Form.* London: Routledge & Kegan Paul, Fourth edition, 1967.

——————————, *Problems of Art.* London: Routledge & Kegan Paul, 1957.

LODGE, RUPERT, C., *Plato's Theory of Art.* London: Routledge & Kegan Paul.

MARGOLIS, JOSEPH, ed., *Philosophy Looks at the Arts : Contemporary Readings in Aesthetics.* New York: 1962.

MARITAIN, JACQUES, *Art and Scholasticism.* Tr. by J.F.S. Canlan. New York: Charles Scribner's Sons, 1943.

OSBORNE HAROLD, ed., *Aesthetics in the Modern World.* London: 1968.

PANDEY, K.C., *Comparative Aesthetics.* Vol. I. *Indian Aesthetics.* Benares: Chowkhamba Series, 1950.

THAMPI, MOHAN, G.B., "*Rasa* as Aesthetic Experience". *Journal of Aesthetics and Art Criticism.* Vol. XXIV. No. 1. Part I. Fall, 1965.

TAGORE, RABINDRANATH, *On Art and Aesthetics.* New Delhi: Orient Longmans, 1961.

——————, *Creative Unity.* Indian ed. London: Macmillan, 1950.

——————, *Personality: Lectures Delivered in America.* London: Macmillan, 1959

RADHAKRISHNAN, S., *Indian Philosophy* in 2 Vols. London: Allen & Unwin, 1958.

READ, HERBERT, *Forms of Things Unknown: Essays Towards an Aesthetic Philosophy.* London: 1960.

RICHARD, I.A., *Principles of Literary Criticism.* London : Routledge & Kegan Paul Ltd., 1963.

SANTAYANA, GEORGE, *Sense of Beauty.* New York: Charles Scrinber's Sons, 1963.

TOLSTOY, LEO, *What is Art ?* Tr. by Alymer Maude. London: Walter Scott., Ltd., 1938.

VIVAS, ELISEO and KRIEGAR, MURRAY, *Problems of Aesthetics: A Book of Readings.* New York, 1963.

WEITZ, MORRIS, ed. *Problems of Aesthetics: An Introductory Book of Readings.* New York, 1959.

WHALLEY GEORGE, *Poetic Process.* London: Routledge & Kegan Paul, 1953.

SELECTED SANSKRIT WORKS

Dhvanyaloka of Anandavardana, with commentaries by Abhinavagupta and Ramasaraka, ed. by Pandit Pattabhirama Sastri. Chowkhamba Series, Benares, 1940.

Kavyadarsa of Dandin, edited and translated by O. Bohtlingk, Leipzig, 1890.

The Kavya Prakasa of Mammata, with the commentary by Abhinavagupta (the *Abhinavabharati*) editted by Manavalli Ramakrishna Kavi, Gaekwad Oriental Series, Baroda.

The Natyasastra, A treatise on Hindu Dramaturgy and Histrionics, by Manomohan Ghosh. The Royal Asiatic Society

of Bengal, Calcutta, 1950. Completely translated from the original Sanskrit.

The Sahityadarpana of Visvanatha by P.V. Kane, with exhaustive notes and the History of Sanskrit Poetics, Bombay, 1951.

The Vyaktiviveka of Mahimabhatta, ed. with a commentary of Ruyyaka and the Madhusudhani commentary by Madhusudana Misra. Chowkhamba Series, Benares, 1936.

Index